IMAGES
of America

ROLLINS PASS

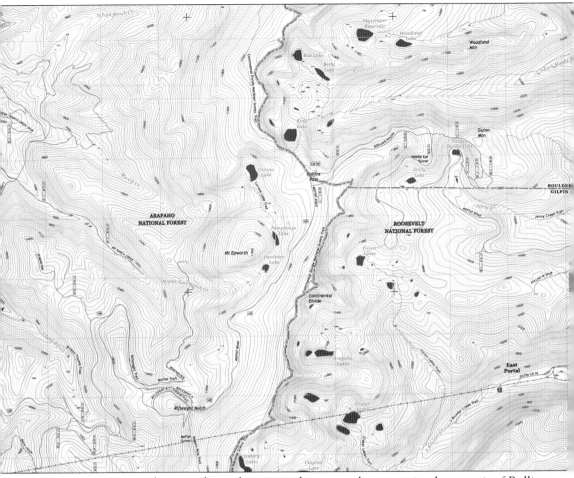

This 2016 topographic map shows the surrounding areas that comprise the summit of Rollins Pass. The contours provide ample challenges for the hiker; the vast number of lakes hold tests for the piscator. This land has been in continuous use for millennia and the views are exceptional. (US Geological Survey.)

ON THE COVER: The Rocky Mountain Climbers Club recreates by the shores of Pumphouse Lake on Rollins Pass around 1920. Railroad advertisements stoked the fires of tourism, offering a glimpse of "the top of the world." Today, this historic site is renowned as a premier recreation spot nestled in the Colorado mountains. The untapped wilderness reinvigorates the soul—Rollins Pass is a treasure to behold and cherish. (Boulder Historical Society Collection of the Carnegie Branch Library for Local History.)

IMAGES
of America

ROLLINS PASS

B. Travis Wright, MPS, and
Kate Wright, MBA
Foreword by Jason M. LaBelle, PhD

ARCADIA
PUBLISHING

Published by Arcadia Publishing
Charleston, South Carolina

Printed in the United States of America

Library of Congress Control Number: 2017943340

For all general information, please contact Arcadia Publishing:
Telephone 843-853-2070
Fax 843-853-0044
E-mail sales@arcadiapublishing.com
For customer service and orders:
Toll-Free 1-888-313-2665

Visit us on the Internet at www.arcadiapublishing.com

*To our families and friends—the breathtaking views we
share make the bumpy road worth the journey.*

CONTENTS

FOREWORD

The historian Marshall Sprague once wrote of the "Great Gates" guarding the rugged Rocky Mountains and their importance to history. These gates were passes—serving to funnel humans and animals across the mountains and conveniently from one drainage to the next. Rollins Pass of the Colorado Front Range certainly deserves company among the list of Great Gates defining the history of the American West.

In this well-illustrated and researched work, Travis and Kate Wright lead the reader through the history of Rollins Pass—from ancient Native American hunting sites spanning the last several thousand years, to the building of the first roads across the divide in the 1870s, and then later to the construction of the near-mythic Moffat Road in the early 20th century and subsequent use by both railroad workers and train tourists. Today, Rollins Pass is a popular spot for fishing and hiking as well as enjoying nature and history. The many images in this book, and the stories behind them, document just a fraction of the ways humans have used this special place.

I would like to ask the reader a big favor: love and cherish this place as do the Wrights. Explore and enjoy the many lakes and trails within the Indian Peaks and James Peak Wilderness Areas but travel lightly. Think about the immense time humans have used this fragile place, and learn to appreciate how you can visit and contemplate this history. Glimpses of the past can be seen in the artifacts and ruins of structures left scattered across the pass. Enjoy them for what they are, as ways for you to reflect on the past and to also think about your personal present. If you find artifacts, please leave them where they are, taking only photographs to document their presence and sharing this information with interested archaeologists, historians, and land managers. Together, we can piece together new chapters regarding this most magnificent of places and assure that future generations can also visit and appreciate the things that have made Rollins Pass a "Great Gate" for many millennia.

—Jason M. LaBelle, PhD
Associate Professor, Department of Anthropology
Director, Center for Mountain and Plains Archaeology, Colorado State University
President, Colorado Council of Professional Archaeologists (2017–2018)
Past President, Colorado Archaeological Society

Acknowledgments

The authors would like to acknowledge this book would not have been possible without the generous contributions of time, photographs, research, and knowledge shared by Dr. Jason LaBelle of Colorado State University (CSU); Larry Fullenkamp, Abraham Thompson, and Sue Struthers of the US Forest Service (USFS); Dan Davidson and Paul Knowles of the Museum of Northwest Colorado (MNWC); and Tim Nicklas and Patty Madison of the Grand County Historical Association (GCHA). A warm thank-you is given for the rarely seen gems as well as information provided by Dr. David Forsyth of the Gilpin Historical Society (GHS); Steve Richardson of the Cawker City Museum; Dr. Jerome Rose of the University of Arkansas; Dr. Karl Birkeland of the National Avalanche Center; William Stone and Pamela Fromhertz of the National Oceanic and Atmospheric Administration's National Geodetic Survey; John Kosovich of the US Geological Survey; Hope Arculin, Marti Anderson, and Peter P. Brady of the Carnegie Branch Library for Local History in Boulder; Holly Geist at Denver Water; Melissa VanOtterloo at History Colorado; and Coi Drummond-Gehrig at the Denver Public Library.

All of you protect, preserve, and propagate knowledge, data, and information to keep history alive and meaningful; your work gives voice to those who lived, worked, and died on Rollins Pass, and the public owes a debt to the information you maintain and the education you generously share with residents of and tourists in Colorado. It was an incredible honor to have access to your archives for the benefit of sharing the storied history of Rollins Pass, beyond the short times when trains and automobiles accessed the mountains. Many pictures are from the collection of John T. Trezise, a locomotive engineer whose collection of snapshots reveal the unseen Rollins Pass; John, may you rest in peace having found a form of immortality within these pages. We thank the many experts who comprehensively reviewed our manuscript to ensure accuracy. To Jason and Larry—thank you for our summers together where you transported us back in time to see this incredible place as it once was and for guiding us and others on how it should best be preserved.

INTRODUCTION

Sixty-five years before boot prints would be made in the lunar dust, an equally ambitious plan was enacted in the mountains of Colorado in what would become known as one of railroading's greatest achievements—the construction of the highest adhesion (non-cog) standard railroad grade in North America. Like President Kennedy, David Moffat, who was president of the Denver, Northwestern & Pacific Railway, would never see the culmination of his dreams realized—the construction of a massive tunnel bored through the Rocky Mountains that trimmed miles off the journey instead of going around or over the ageless mountain range towards Craig, Colorado, along tracks known as the Moffat Road.

Before any railroad achievements could be penned into the history books, the Rocky Mountains—and Rollins Pass—first needed to come into existence through intense geological forces. Rollins Pass was created as a result of the Laramide orogeny, which occurred between 70 and 40 million years ago. During the Cenozoic era, deformative and erosive forces carved Rollins Pass as a low saddle on the Continental Divide, comparatively speaking. At 11,677 feet above sea level, Rollins Pass looks attractive to divide crossings when alternative mountain passes vary between 12,000 and 14,000 feet in elevation and do not have as moderate of gradients.

Rollins Pass has been known by several names. Boulder Pass was the original name, which later became Rollins Pass, named after John Rollins. The railroad station at the summit was named Corona, consequently Corona Pass is a variant name used by the railroad for tourism purposes. Today, Grand County refers to the pass by this appellation almost exclusively. However, Rollins Pass is the official name used by the US Geological Survey and is also the name officially recognized by the US Board on Geographic Names. In fact, the name "Corona Pass" does not exist in the official federal government geographic nomenclature—only Rollins Pass.

Native Americans were the first to be aided by the lower elevations found on Rollins Pass more than 10,000 years ago, and it was here they camped and later constructed rock walls to subtly influence the flow of large game migrating across Rollins Pass. Professional archaeologist Dr. Jason LaBelle, who studies and conducts fieldwork on Rollins Pass, states that these large-scale communal hunting grounds and game drives are "one of the greatest concentrations of ancient hunting structures documented in North America." Dr. LaBelle and his teams have documented miles of rock walls and hundreds of hunting blinds strategically placed by indigenous peoples to prey upon migrating elk and bighorn sheep. Native Americans utilized Rollins Pass for thousands of years until the mid-19th century.

On September 18, 1873, the Denver-based *Rocky Mountain News* published a letter to the editor: "[On] this pass are what, upon careful investigation, I conclude are the remains of an ancient settlement . . . Here are stone walls . . . miles in length, compact and regular and giving every evidence that they were built by human hands . . . [Nearby], and on either side of the walls, are numerous rock pits, round, and . . . deep. . . . In [a] stone corner of the field I found a bow, about three feet in length, made from hemlock wood, and having the appearance of great antiquity." John

Quincy Adams Rollins was the author of this letter, and he was exploring, in detail, what would later become known as *his* pass; he would build a toll wagon road that would connect Boulder to the Middle Park Basin (current-day Winter Park and Fraser Valley) that would overlap the dusty paths well-worn by Native Americans for thousands of years.

In July 1862, Captain Bonesteel, along with his wagon train, made the first (nonindigenous) recorded crossing of Rollins Pass. Mormons brought wagons over this route in 1865; and in 1866, wagons and wagon trains associated with livestock began to summit Rollins Pass on the way to Middle Park. John Rollins and his team began to officially transform Boulder Pass into Rollins Pass—in fact, the name change resulted as a suggestion from the developer hired by Rollins himself.

Wagoneering was tough: from heavy loads and steep talus inclines to hard frosts, summer storms, early snows, broken wheels, sharp rocks, and stubborn mules. As Samuel Bowles writes, "But there was exhilaration in the unseasonable struggle; there was something jolly in the idea of thus confounding the almanacs, and finding February in August." Wagons continued over Rollins Pass until 1880, when railroad scouts began to follow much of the pass as the primary route over the mountains.

Early attempts at running rails over Rollins Pass were made in the 1880s but those efforts met premature ends due to financial issues. In 1903, the ties, tracks, and ballast were laid over the dust and rock. In 1904, the temporary Hill Route opened, and the first train launched from the Moffat Depot at Fifteenth and Bassett Streets in Denver and traveled through dozens of tunnels and into Rollinsville in western Boulder County. From there, the track would immediately gain elevation—climbing four feet of vertical for every 100 feet traveled; a four percent grade was pushing the limits of an adhesion standard-gauge train. The train followed steep switchbacks to quickly gain elevation: Giant's Ladder was how the train ascended the Atlantic slope of the Continental Divide and the great Southern Rocky Mountains. The train crossed trestles and continued the punishing climb. After completing a near circle around an idyllic alpine lake, the train snaked through paths cut through the krummholz and columbine flowers blooming beside massive snowdrifts. The train threaded the eye of the needle: a small 170-foot-long tunnel above the tree line, then crossed two trestles that precipitously clung to a mountainside and reached the summit at Corona—having burned between 16 and 20 tons of coal since departing Rollinsville. This route would be the highest standard railroad grade in North America—a record still standing today.

The train and its occupants would begin to feel the favorable push of gravity as it pitched over and began descending towards Middle Park and Grand County, zipping past Pumphouse and Deadman's Lakes, rounding the corner at Ptarmigan Point, taking on water at Sunnyside, and click-clacking across the Riflesight Notch Trestle where it arced around the hill and lost 150 feet of elevation just in time to go into Tunnel No. 33, directly under that same trestle. Exiting the tunnel, it rounded a curve, crossing over marshy terrain and across two more trestles that bridged the gap between something and nothing—it sped downhill past timber-loading docks and settlements towards Ranch Creek Wye. It was here that the workers, who lived year-round in housing, refilled the thirsty boilers before the train pressed onwards towards the town of Arrow, then to Irving Spur, and ahead to the railyards at Tabernash.

There were train wrecks, derailments, and even loss of life. All of this constituted the difficulty of pushing and pulling trains over the Continental Divide for two decades. During that time, other pushing and pulling was happening, too—but this was political maneuvering to secure funds and bonds to finally build and open the Moffat Tunnel, as the Hill Route over Rollins Pass was always meant to be temporary. It was inordinately expensive to hole through the shoulder of James Peak, removing an estimated 1.5 million tons of rock, to make the Moffat Tunnel a reality. The mountain itself opposed the construction efforts, from taking the lives of workers through cave-ins to the constant deluge of alpine lakes that seeped into the tunnel. However, progress was steadily made, and the jubilant whistle and clanging of the bell on the first train moving through the Moffat Tunnel in February 1928 was simultaneously the death knell of trains on

Rollins Pass. It would take seven years for the Interstate Commerce Commission to grant approval for the rails on Rollins Pass to be dismantled, and one year later, in 1936, the rails and ties were removed. Also within the 1930s, the pioneer bore that was used to facilitate the construction of the Moffat Tunnel was expanded and converted into a water tunnel to shunt water from the mountains towards Denver.

Rollins Pass, having been pounded by trains for more than a quarter century, found respite for two decades as a primitive road before Lt. Gov. Steve McNichols officially reopened Rollins Pass to vehicular traffic in 1956. In 1979, Needle's Eye Tunnel, having stood for 75 years, began showing its age with the first modern signs of structural failure: a rockfall inside the tunnel closed the connection between both sides of the pass. Ten years later, in 1989—after hundreds of individual contributions and the participation of at least five different local, state, and federal agencies to fund engineering studies and assessments—the tunnel was strengthened with lengthy rock dowels and stout wire mesh, and it was thought to be safe for vehicular traffic once again.

In 1990, Denver firefighters were passing through Needle's Eye Tunnel on a summer mountain Jeep tour when several thousand pounds of rock unexpectedly fell from the ceiling of the tunnel injuring Assistant Fire Chief and US Navy veteran Tom Abbott, resulting in a below-knee amputation. The tunnel remains closed indefinitely, and smaller rockfalls continue to occur. Proposed solutions to strengthen the tunnel are costly, especially for a thoroughfare that sees less than 90 days of use in an average year and could erase some historical character of the tunnel: shotcrete would certainly cover up soot-stained rocks bearing silent witness to Moffat's pioneering strategy of running rails at historic altitudes. Every other railroad tunnel on Rollins Pass itself has served its intended purpose and has collapsed.

As was the case during the zenith of the railroad era, Rollins Pass continues to draw tourists. The views are unbelievably spectacular, and each twist and turn reveals another angle of a familiar vista that never seems to get old. The pass has two natural enemies. The first is time—in the form of long-standing erosive forces through wind, rain, fire, and snow—threatening to erase what has been built over thousands of years. The second threat is more pervasive. Improvements to the road and tunnel would undoubtedly lead to increased use—from 2010 to 2016, Colorado, especially along the Front Range, saw a 9.7 percent population increase. An unintended consequence of increased visitation would be the accelerated destruction of the cultural history on Rollins Pass before it has the chance to be appropriately recorded and protected. Professional archaeologists estimate only 25 percent of the intricate layers of history on Rollins Pass have been systematically explored and documented.

This legendary slice of Colorado is surrounded by many myths and factual inaccuracies; this book tries to dispel fiction wherever possible. Yet it is easy to understand how such legends start—the inflexibility of Rollins Pass demanded the very best humanity had to offer and the challenge was repeatedly accepted to not only endure and survive but also to thrive and flourish. Rollins Pass and its chronicles conveyed to each generation are timeless because at the beating heart of all the stories lives the pioneering spirit of consummate grit and tenacity while daring nature, dreaming big, and never losing sight of that magnificent view. Over the eons, heroes and legends rose from the dust of that timeless ribbon of road winding its way up and down the mountains of Rollins Pass.

One

ROCK WALLS AND THE GREAT HUNT
8000 BC–AD 1850

Native Americans were the first peoples to set foot on the pass shortly after the last ice age, around 10,000 years ago. Ancient spear points found near the summit of the pass testify to their presence. Who was the first person to discover the pass and what did he or she call it? Time has lost most of these early stories of the past, but one thing that remains are the broken and scattered stone chips discarded while making tools.

The First Peoples were hunter-gatherers, who for millennia harvested wild plants and animals along the Colorado Front Range as part of their seasonal round. Over time, native peoples noticed that big game also favored this low pass across the mountains between Ranch Creek and the upper reaches of Boulder Creek.

Native peoples began the first of many alterations to the pass. Low rock walls, some spanning thousands of feet, were erected from nearby boulders. The walls subtly altered animal movement, much like cones in a construction zone guide the procession of traffic. Migrating animals unknowingly walked into a snare: the many hunting blinds constructed at the terminus of the rock wall branches concealed waiting hunters who ambushed the big game as they neared the end of the trap. For the early hunter, these "game drives" improved their odds for a successful hunt and ensured food for their families. To native peoples, these great hunts were chances to come together, to bond and connect with distant kin, and share the rewards of the hunt. It was an essential part of their lives.

At select places on the pass, archaeologists have documented fragments of rock, called flakes, which were whittled away while making and resharpening arrowheads and other tools used for the hunt. The humble flake provides a direct connection to the hands that shaped it thousands of years ago. If one comes across stone tools while visiting the pass, please appreciate the moment and cherish the connection but leave it behind as it helps tell the story of what happened long ago on the alpine tundra of Rollins Pass.

NOTICE

THE AREA BEHIND THIS SIGN IS PROTECTED UNDER THE AMERICAN ANTIQUITIES ACT OF JUNE 8, 1906

DO NOT APPROPRIATE, EXCAVATE, INJURE OR DESTROY RUINS, MONUMENTS OR OBJECTS OF ANTIQUITY

 VIOLATIONS PUNISHABLE
BY
$500 FINE, 90 DAYS IMPRISONMENT
OR BOTH

UNITED STATES DEPARTMENT OF AGRICULTURE - FOREST SERVICE

Rollins Pass is listed in the National Register of Historic Places and all artifacts—from the prehistoric to the historic—are objects of antiquity and are protected by many cultural laws. This includes the ancient Native American rock wall, pictured below. The pass contains countless treasures, which are being studied and documented by universities and government agencies. Sadly, the material record of Rollins Pass is illegally carried away each year in the backpacks of well-intentioned visitors who want a souvenir. Each artifact has important scientific and cultural value and theft harms the historical record of accomplishments made on this beloved pass. Please preserve the area for future generations: be sure to take only photographs, leave only footprints, and share discoveries with those researchers dedicated to telling the story of this important place. (Above, USFS; below, GCHA.)

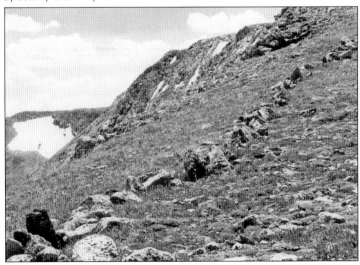

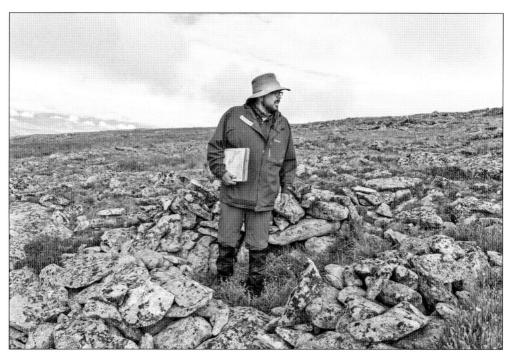

Few know of the thousand-year-old Native American hunting structures scattered across Rollins Pass. C.A. Deane, a government surveyor, first interpreted the Rollins Pass game drive complex in 1869, and his interpretation was rounded out by "Commodore" Decatur, a trader familiar with Native American traditions. John Rollins himself described the walls in 1873. Archaeologists Byron Olson and James Benedict worked on Rollins Pass through the 1960s and 1970s, and in 2009, professional archaeologist Dr. Jason LaBelle, above, assessed the Rollins Pass region for archaeological reinvestigation. Since then, Dr. LaBelle has documented miles of rock walls and hundreds of hunting blinds, pictured above and below, strategically placed by the indigenous peoples to prey upon migrating animals. He stated these game drives are "one of the greatest concentrations of ancient hunting structures documented in North America." (Above, CSU; below, authors' collection.)

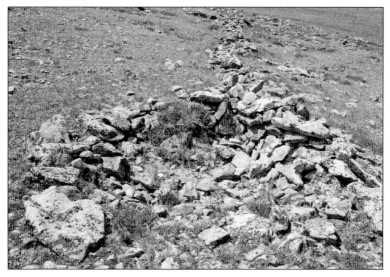

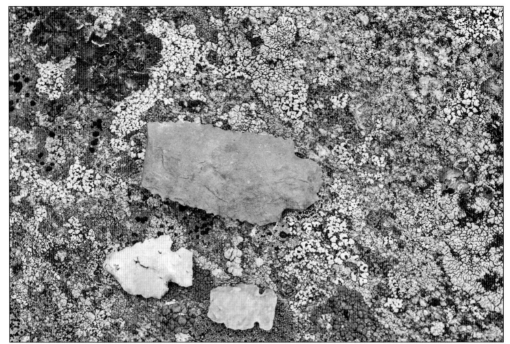

Dr. LaBelle's archaeology teams also document weaponry used on Rollins Pass. Three artillery examples, two of which are missing tips, are shown here. Stone tools cannot be radiocarbon-dated, so lichenometric dating is instead employed. The exposed lichen, particularly *Rhizocarpon geographicum* (appearing slightly whiter in this grayscale image but brighter green in color), is used to aid archaeologists in dating the construction of the rock walls and game blinds. (CSU.)

According to Dr. LaBelle, the 12 game drives on Rollins Pass "cannot be evaluated as a 'snapshot' of a hunting event that can be linked to a single era or climatic event . . . even though it is one of the best dated game drives in all of North America. Instead it must be viewed as a landscape, as an accumulated surface of occupations of varying lengths and intensities." (Rose collection.)

According to Dr. LaBelle's research, these rock walls and game drives were utilized by Native American hunters "during the seasonal migrations of large game, likely in the early to middle fall of the year, before heavy snows covered the game walls. . . . Hunter-gatherer bands participated in the hunt and subsequently shared the yield . . . which also served important social purposes." (CSU.)

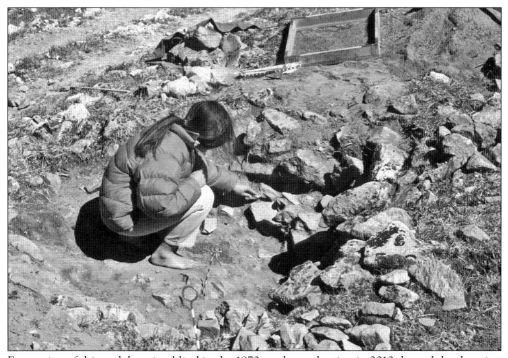

Excavation of this rock hunting blind in the 1970s and reevaluation in 2010 showed that hunting blinds varied between 107 and 298 centimeters in minimum interior width; depth varied from 17 to 108 centimeters, and many are oval or circular in shape. These pits would camouflage hunters and allow them to repair tools while sheltered from the wind. (Rose collection.)

Dr. LaBelle states that typically, game drives are "configured to form a V-shaped funnel into which game were coerced into a progressively confined space, eventually leading to an intercept area surrounded by blinds." The rock walls "take advantage of the behavioral tendencies of bighorn sheep," causing the animals to move to "safer terrain" uphill, where they are ambushed. These game drives use the native landscapes and hide in plain sight throughout Rollins Pass. (CSU.)

Dr. LaBelle surmises why Native Americans started hunting above timberline: "If rapid population growth occurred during this time, the exploitation of foothills resources would have had to keep pace, possibly to the extent of overexploitation and eventual resource depression. As encounter rates and subsequent resource yield declined, foragers would have been forced to expand their diet breadth to include the resources of the alpine zone." (CSU.)

Two

HORSE AND WAGON
1862–1880

In the decade where Louis Pasteur invented pasteurization and Alfred Nobel created dynamite, the first recorded crossing of a wagon train on Rollins Pass was accomplished in 1862. There are relatively few photographs from this era—and judging from the photographs that do exist, traversing Rollins Pass must have been a staggering and formidable task. The travels and travails are well documented by Samuel Bowles, who speaks bluntly of the summer storms that interfered, "Hell was pleasanter and safer than a thunderstorm on [that] range." He talks of mules and horses in the storm that "winced under the blast" and of "difficulties [being] frightful"—Bowles goes on to explain that very few wagon wheels "remain[ed] whole" after encountering the mud, rocks, and rivers on Rollins Pass.

Despite the difficulties encountered on these wagon journeys, the sensory feast casts a permanent spell on its visitors. Bowles captures, in writing, the first impressions of the beauty of which Rollins Pass has always been known: "Everywhere about us, where the snow and the rocks left space, were the greenest of grass, the bluest of harebells, the reddest of painter's brush, the yellowest of sunflowers and buttercups. All, with the brightest of sun and the bluest of sky . . . that we were in raptures with the various beauties of the scene, and feel still that no spot in all our travel is more sacred to beauty than this."

Colorado pioneer John Quincy Adams Rollins began his exploration of what would become Rollins Pass, and he wrote the editor at a Denver newspaper of his findings. Rollins speaks of "beautiful, quiet pools, fringed by overhanging willows, where speckled trout 'most do congregate,' alternated by rushing cascades and by wide-spread, pebble-bottomed shallow stretches, where the waters glimmer in the sun." Ironically, Rollins claims that he is "neither a 'literary' [n]or 'scientific gent'" yet his reports of the lands beyond Rollinsville are filled with euphony and literary genius; it is no wonder the place would soon be named after him: Rollins Pass.

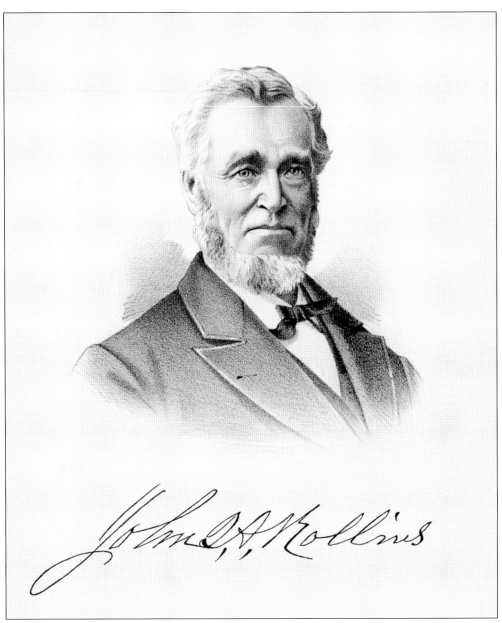

This is the legend himself—the name on the front cover of this book: John Quincy Adams Rollins. This is an exceedingly rare image, first printed in the *History of Clear Creek and Boulder Valleys* in 1880, and is reprinted by Arcadia Publishing nearly 14 decades later. Rollins was born in New Hampshire and joined the ranks—and naturally the history books—as a pioneer from a family of Colorado pioneers. In Middle Park, Rollins built the first bridge over the Grand (Colorado) River; in Rollinsville, Rollins was elected mayor in 1881. Four days after his 78th birthday, Rollins died on June 20, 1894, and is buried in Denver's oldest operating cemetery, Riverside, in block 5, lot 12. His simple tombstone reads, "John Q.A. Rollins | Colorado Pioneer of Rollinsville and Rollins Pass," yet his legacy is bequeathed to future generations; the spirit of Rollins is eternal. (Courtesy of the Carnegie Branch Library for Local History.)

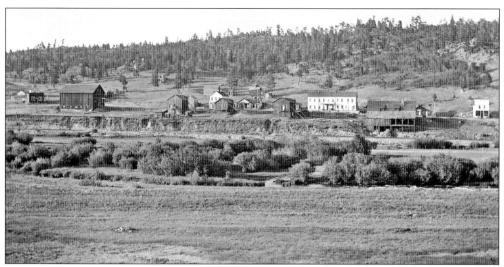

Pictured is a 1912 view of Rollinsville, formerly "Gold Dirt." John Q.A. Rollins established a quartz mill here in the winter of 1860–1861. Rollins used his new wealth to build and fund roads within Colorado. His first road, a toll wagon road, stretched 40 miles from Rollinsville to Hot Sulphur Springs and cost $20,000. The toll structure is detailed in the caption on page 22. (MNWC.)

The first wheeled vehicles to cross Boulder Pass were wagons. Throughout this period, as well as during the railroad era, many log cabin communities sprang up throughout the pass, typically tucked away in forests or located at timberline. In 2016, a US Forest Service archaeological expedition documented the existence and locations of skillets, stoves, cutlery, pottery, glassware, animal bones, and storage pits (for food) among many settlement ruins. (USFS.)

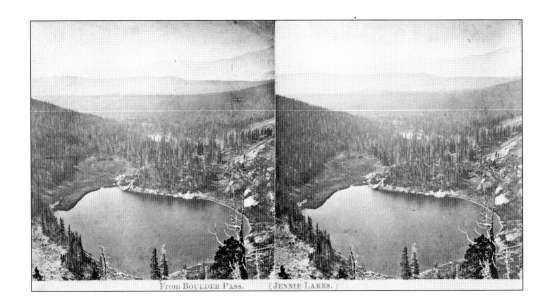

From BOULDER PASS.　　(JENNIE LAKES.)

These 19th-century stereocards reveal views from the wagon road days on Boulder Pass. Both stereographs show Yankee Doodle Lake before it was encircled by the railroad and before the mound of granite debris was added to the northern part of the lake, closest to the camera. Incredibly, Yankee Doodle Lake is a source of confusion, some of it started by John Q.A. Rollins. In his writings, he refers to a town of Yankee Doodle at "Lake Jennie," but this has been interpreted by modern US Forest Service archaeologists as Yankee Doodle Lake given the descriptions provided by Rollins himself—and given that the wagon road did not travel by what is known now as Jenny Lake. Instead, the wagon road diverged to journey up the eastern ridge of Guinn Mountain. (Above, MNWC; below, LaBelle.)

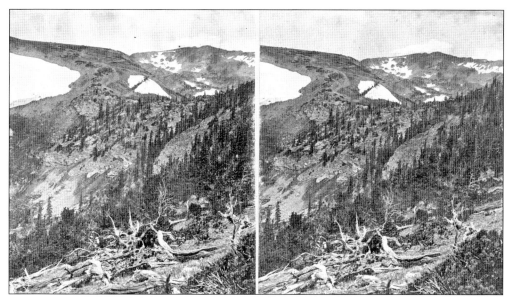

Pass crossings increased from 1865 to 1868. One hundred Mormons with a team of 39 wagons destined for Utah utilized the pass as did others, including Col. William Johns, of the California Volunteers, who brought 150 men and 22 wagons; future vice president Schuyler Colfax; author Samuel Bowles; and William Byers, founder and editor of the *Rocky Mountain News*, who had experience as a territorial surveyor. On February 6, 1866, the Council and House of Representatives of Colorado Territory passed an act signed by the governor approving the wagon road as the "Middle Park and South Boulder Wagon Road Company." Records show the incorporators as "John Q.A. Rollins, Perley Dodge, and Frederic C. Weir." In 1873, Rollins built the route over Boulder Pass, which later became Rollins Pass. (Above, LaBelle; below, Denver Public Library, Western History Collection, Call X-19306).

These views are near the summit of Boulder Pass, now Rollins Pass. Per the recollection of old settlers, the going was tough: everyone, women and children included, needed to carry contents of their wagons up the steep hills. Some of the weary were buoyed by hymns sung aloud. The wagon road had one tollgate and the following rate structure: "For each vehicle drawn by two animals, two dollars and fifty cents; for each additional two animals, twenty-five cents; each vehicle drawn by one animal, one dollar and fifty cents; horse and rider and pack animals, twenty-five cents; loose stock, five cents per head . . . horse with rider, or pack animal with pack, ten cents." The cost for nonpayment of a toll was the same as causing intentional damage to the road: $25. (Above, LaBelle; below, Trezise.)

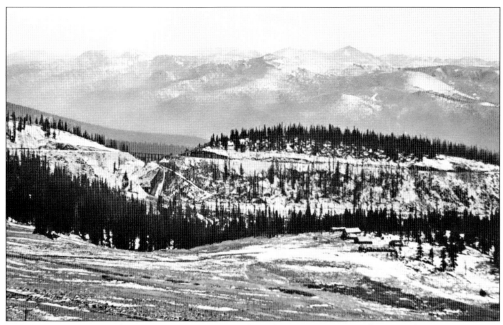

While this photograph from Ptarmigan Point (on the west side of Rollins Pass) was taken after the railroad erected the Loop Trestle seen in the distance, it reveals a wagon-era settlement of log cabins along timberline in the field towards the right center of the scene before it was lost to history. On a US Forest Service archaeological visit to the site in 2016, the authors found evidence of dishware, silverware, horseshoes, graves, and more. All artifacts were photographed and notes were made to document scale, cardinal direction, GPS coordinates, and context to ensure history is preserved for the next generation. (Above, LaBelle; below, authors' collection.)

Above, the early settlers in Grand County left behind more than artifacts, such as flatware, for modern archaeologists to find and study; they also willed future generations the legacy of a forest. Below, settlers in Winter Park and the Fraser Valley deliver lodgepole pinecones to the Idlewild Seed Extractory, which was near the Idlewild Ranger Station. The seeds extracted from these pinecones would later be used to revegetate local forests. The hill in the background designates the initial western slopes of Rollins Pass. (Above, authors' collection; below, USFS.)

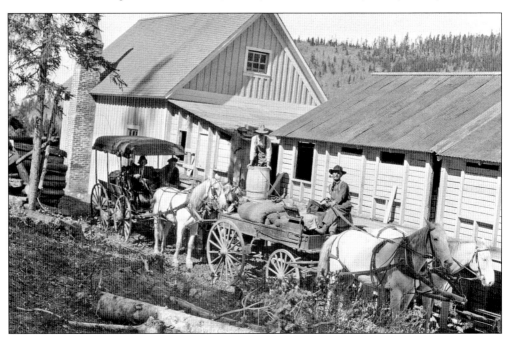

Three

IRON AND STEAM
1880–1928

At the turn of the 20th century, civilization began to demand that machines do more than perform, they should also astonish. Orville and Wilbur Wright took to the skies in 1903, and one year later, David Moffat's Denver, Northwestern & Pacific Railway also took to the skies—and the first train summited the Continental Divide on Rollins Pass in September 1904. After September, a cruel reality would set in: winter never really vacates Rollins Pass, it only eases for a few months per year. More specialty machines were needed to make the train route on Rollins Pass feasible, such as mallets and rotaries. A mallet is a compound articulated locomotive, two engines in one with the ability to climb steep hills and take sharp turns—fortunately for the railroad, mallets were first introduced to the United States from Europe that same year. The other technology, a rotary, served one purpose: the indiscriminate ingestion and expulsion of snow to clear the tracks. This massive snowplow with its gigantic blades was pushed by other engines to ensure the rails remained clear.

During this time, society realized that these magical machines had dreadful shortcomings, especially when it came to ice and snow. The *Titanic* collided with an iceberg and slipped under the icy waves eight years after Rollins Pass opened. Trains succumbed to the wintery elements as well—some were stuck for weeks in attempts to transit Rollins Pass. Many photographs on the following pages were taken in the winter months; the sight of frozen equipment and equally frozen men speaks to the determination and unsinkable human spirit that pervaded operations on Rollins Pass.

Despite the omnipresent struggle, from snow removal to brake failures, railroad workers and visitors alike were enchanted by the scenery. No matter the season, there always seemed to be time for the veneration and wonder of the views that can be seen from the summit; the top was named Corona—the Latin word meaning "crown." Railroad workers emphasized that the crown at "the top of the world" was found on Rollins Pass.

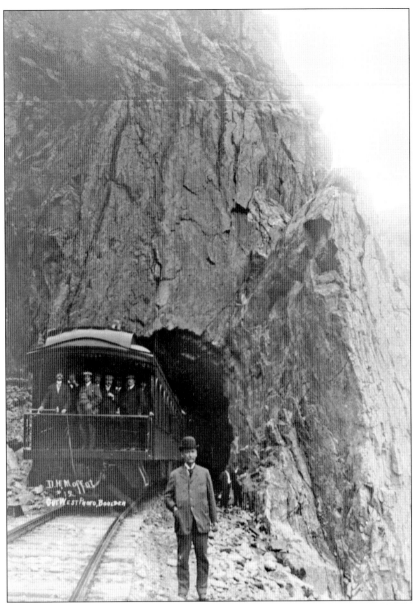

David Halliday Moffat Jr. was born on Monday, July 22, 1839, in Washingtonville, New York. Moffat himself was a warm, larger-than-life character who was never too busy to listen and lend assistance whenever possible; a man like this becomes legendary and begets legends. Moffat's leadership style was atypical of a company president—past or present. Railroad workers recalled that he would regularly chat with them in the crew compartment of the locomotive, as the train moved from town to town. When Moffat's investors were riding in his private railroad car, *Marcia*, Moffat insisted that his workers ate before anyone else. Moffat's first-class treatment of his mountain men guaranteed they gave him their very best as well. Moffat hired youth with youthful indiscretions. Dan Crane, a former Santa Fe Railway worker, came to Moffat with papers, "Discharged for insubordinating [*sic*] the road foreman of engines and drinking intoxicating liquors to excess. Services otherwise satisfactory." Crane was hired and worked as an engineer and fireman on Rollins Pass. (GCHA.)

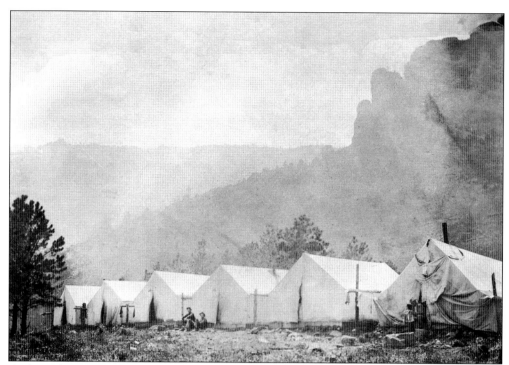

Author Edgar McMechen writes in a footnote of the prior efforts to build a railroad over Rollins Pass: "A brief review will give the reader a better appreciation of Moffat's courage in the inauguration of the *Denver, Northwestern, & Pacific* . . . Boulder, or Rollins Pass, between South Boulder Creek and Middle Park. *GHS, Jefferson, & Boulder County Railroad and Wagon Road* (A.N. Rogers' line) in 1867; *U.P.* in 1866; *Kansas Pacific* in 1869; *Colorado Railroad* (B. & M. subsidiary) in 1884—two tunnels located; *Denver, Utah & Pacific* in 1881 (construction started and tunnel located)." These early tunneling attempts can be seen today—Guinn Mountain at Yankee Doodle Lake and the other through the southern cirque at King Lake. Above, construction camps housed men building Moffat's dream; below, heavy equipment carves a grade out of the mountainside. (Both, MNWC.)

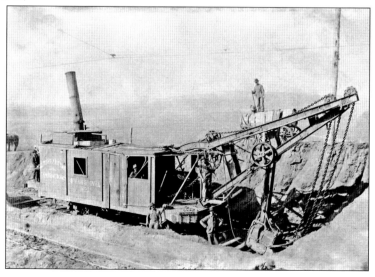

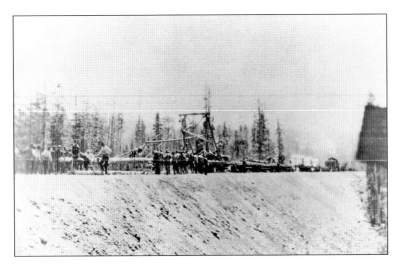

The railroad leased a Roberts track-laying machine to help quickly lay both ties and rails. In optimum conditions, a mile a day was a reasonable target. A series of rollers formed a conveyor so that ties could be rapidly placed as the construction crew moved along the grade. (GCHA.)

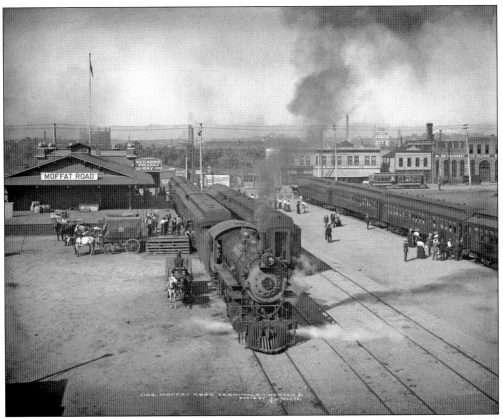

The *Park County Bulletin* of August 17, 1906, reads, "For the first time . . . the Moffat [R]oad has been 'swamped' with excursion business. Sunday, the road sent out six trains and there were fully 150 people turned away. The little depot at Fifteenth and Delganey [sic] streets looked like the entrance to a circus while the crowd was buying tickets." (Denver Public Library, Western History Collection, Call MCC-1104.)

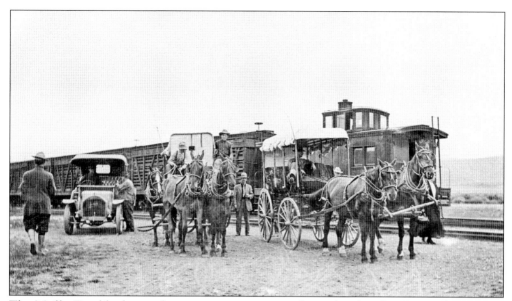

The Moffat Road had several operating companies within a few decades. From July 18, 1902, through April 30, 1913, it was operated as the Denver, Northwestern & Pacific Railway (a railcar bearing these markings can be seen here). From May 1, 1913, through December 31, 1926, it was the Denver & Salt Lake Railroad, and from January 1, 1927, through April 10, 1947, it operated as the Denver & Salt Lake Railway. (GCHA.)

The "Tunnel District" leading out of Denver and through the South Boulder Canyon was a feat of impressive engineering, skill, and cost. In a 15-mile stretch, where each mile cost the railroad $78,000, twenty-nine tunnels were created. Modern-day trains dive in and out of hillsides and mountains carved by Moffat's men. (Trezise.)

A snap from the shutter of a camera forever preserves a picture—still or motion—on halide crystals and a gelatin emulsion later carried to large cities, like Denver, for processing and development. Railroad workers like John T. Trezise, Edward T. Bollinger, and others, including railroad passengers, helped to document the history of steam trains on Rollins Pass. (Trezise.)

The steep four percent grade (four feet of vertical for every 100 feet) can be seen on this leg of the Giant's Ladder, near Rollinsville. Gravity lift—friction caused by adhesion to the rails and air resistance—added 80 pounds per ton on these grades. In 1920, the line over Rollins Pass cost the Moffat Road $800,000 (adjusted for inflation in 2018: $10.27 million) per year. (GCHA.)

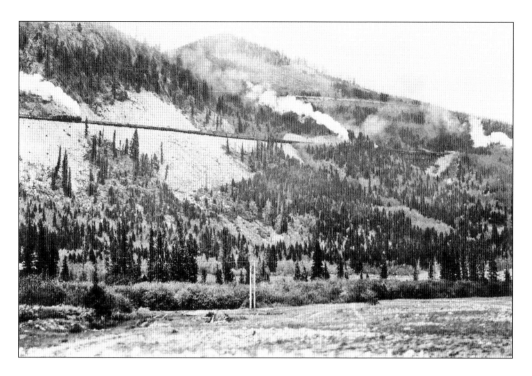

Above, a train climbs Giant's Ladder on the lower east side of Rollins Pass. A trestle can be seen at right. Below, a passenger takes a snapshot from outside a window of the train steaming across a trestle. Due to the chasms that naturally existed between two hillsides or mountainsides, trestles were heavily utilized by the railroad. In fact, according to the mileage and track chart of the Denver, Northwestern & Pacific Railway, records reflect that from Denver to Tabernash, an impressive 67 trestles helped to bridge the gaps. Some were made from steel girders but a clear majority were built from wood. (Above, Carnegie Branch Library for Local History; below, GCHA.)

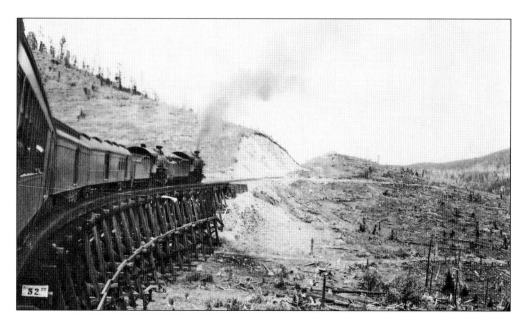

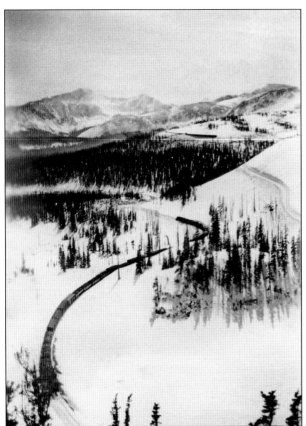

How were potatoes shipped in the winter over Rollins Pass? The front page of the January 30, 1914, *Routt County Republican* has the answer: "The general way of shipping all kinds of merchandise that is apt to freeze or be injured by the cold is to put them into refrigerator cars and have an oil heater in the car. This removes all danger of injury to perishable vegetables." (Trezise.)

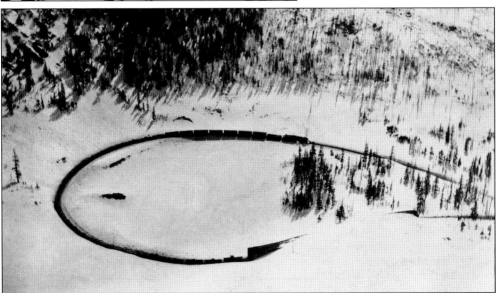

A freight train arcs around Yankee Doodle Lake in the depths of winter. Railroad workers wrote in their memoirs that in the summer and when off the clock, they would try their luck fishing at this lake. No matter the era, fishing tends to be a feast or famine sport. However, workers with leftover dynamite would, instead, blast for fish—finding instant success! (Trezise.)

Dan Crane in his memoirs asserts, "Railroading over [Rollins Pass] was dangerous. It was probably the most dangerous stretch of railroad in the United States—if not the world." Crane was seriously hurt in a snowshed leading into Tunnel No. 32, Needle's Eye Tunnel, seen at the top of the image; directly beneath, a rotary snowplow expels snow onto a frozen Yankee Doodle Lake. (Trezise.)

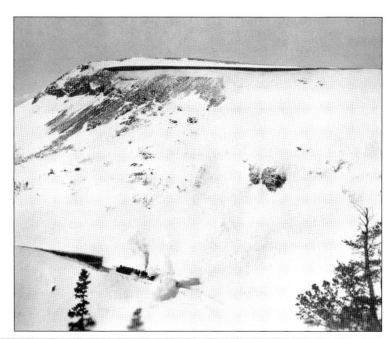

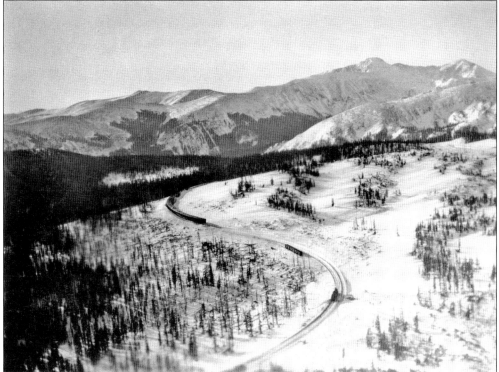

As railroad operations on Rollins Pass matured, areas where trains had become stranded due to lack of fuel were identified. The following summers, railroad teams would deposit emergency piles of coal at those locations in the event future trains needed this providential fuel source. The remnants of midnight patches of coal dust can be seen today southwest of Jenny Lake and at Sunnyside, among other locations. (Trezise.)

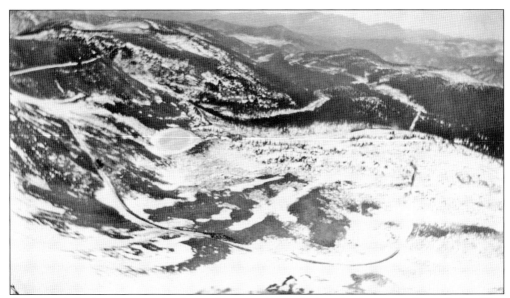

At center left, the near-circular frozen feature is Jenny Lake, also known as Dixie Lake. This lake was dammed to feed water to thirsty railroad boilers, leading several texts to erroneously conclude this lake is a man-made creation. Near the upper left, the snow-covered grade leading to Tunnel No. 32 can be seen. (Trezise.)

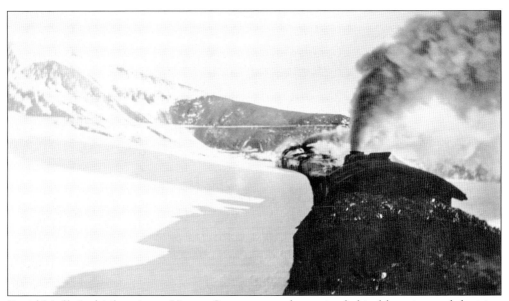

David Moffat's chief engineer, Horace Sumner, was the genius behind locating and devising the route for the Moffat Road to stretch over Rollins Pass. It was Sumner who conceived of and planned everything, from Giant's Ladder to the horseshoe curve around Yankee Doodle Lake to the elegant engineering of the three trestles and tunnel at the Loop. (Trezise.)

A small snowshed can be seen at the top right of the escarpment; this snowshed effectively extends the south portal of Tunnel No. 32. At left, a watchman's house can be seen near the railroad grade. There is also a cabin in the center of the image. None of these structures exist today, emphasizing the importance and necessity to safeguard historical photographs for future archaeology work. (GCHA.)

This is a view looking upwards from the South Fork of the Middle Boulder Creek past slopes of talus towards the longer of the twin wooden trestles constructed above timberline. A train with a heady smokestack and manifest is moving east across the trestle as it begins its initial descent on its way to Rollinsville and ultimately towards Denver, Colorado. (USFS.)

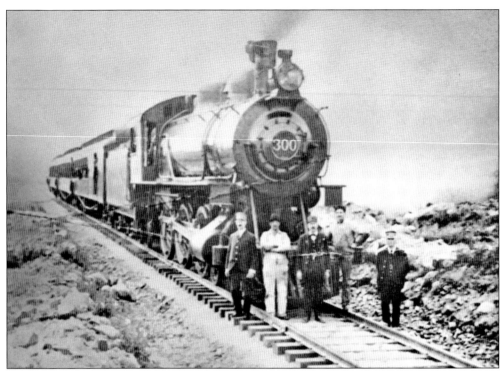

As the first train approached the summit on September 2, 1904, conductor George H. Barnes called out, "Rollins Pass—the Top of the World!" The following day, Mother Nature dropped six inches of wet wintery mix from the heavens, producing a severe contrast to the ease found on the inaugural day of travel. (GCHA.)

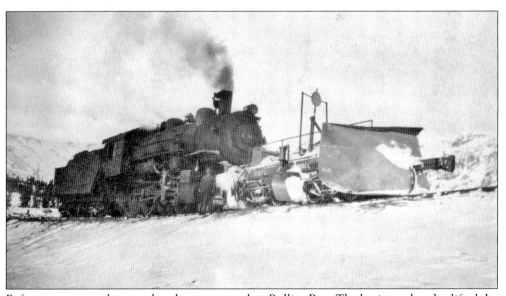

Before rotary snowplows, wedge plows were used on Rollins Pass. The horizontal wedge lifted the snow from the tracks where it met the vertical wedge to push the snow away and towards either side of the tracks. A smaller wedge was located behind the first set of trucks, or wheel sets, to further move stubborn snow from the tracks. (GCHA.)

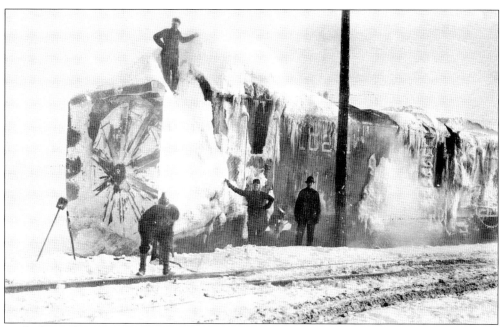

With the unforgiving snows on Rollins Pass, the railroad placed a $22,476 order (adjusted for inflation, $609,000) for its own rotary snowplow. The railroad first used it on February 10, 1905, and immediately damaged the massive blades while the rotary chewed through avalanche remnants; hidden in the snow were sizeable rocks and trees. The rotary was sent to Denver for repair and improvements. (Trezise.)

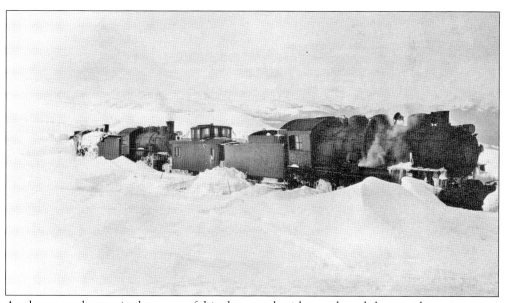

A caboose can be seen in the center of this photograph with an enlarged glass cupola compartment for observing the train at a height that allowed the workers to see up the entire rail manifest to the engines. This nonrevenue-generating railroad equipment often served as crew quarters and usually had a smokestack for exhausting a wood or coal-powered stove. (Trezise.)

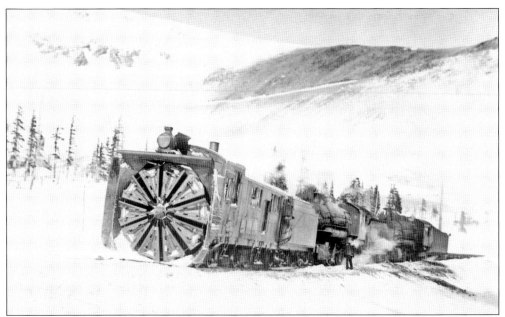

An engineer seems to be evaluating either the tractive capability of the driving wheels or the coupling rod of a mallet (a compound-articulated locomotive, essentially two train engines in one with extra power to ascend mountain passes). In this image scanned directly from the negative, two mallets push a massive rotary snowplow near Jenny Lake on the east side of Rollins Pass. (USFS.)

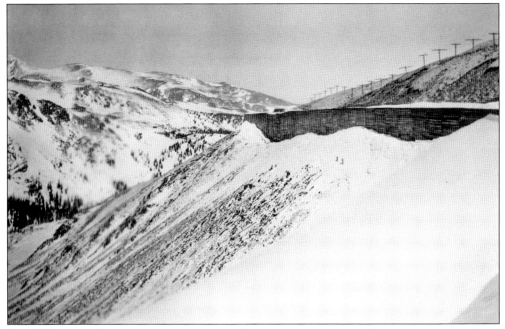

The difficulties of running a high-altitude railroad were immense, and newspaper reports from the era attest to this. In 1918, a fire fanned by 40-mile-per-hour winds claimed several snowsheds and buildings at Corona; that same year, a snowshed collapsed, dumping 18 feet of snow as well as timber on the tracks. (Trezise.)

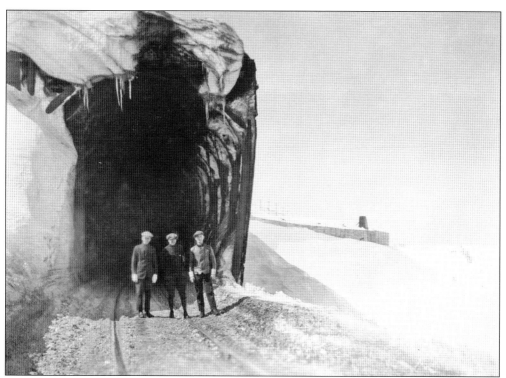

Three railroad workers stand in front of a snowshed near the summit of Rollins Pass. Soot expelled from the locomotives blackens the snow-covered tracks as well as the cornice overhanging the portal of the snowshed. Despite the vents installed in the roof of the sheds to exhaust noxious gasses from the engines, foul air would nevertheless remain inside the snowshed. (Trezise.)

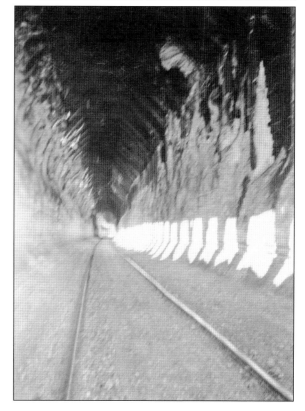

This snowshed interior reveals a hidden and frozen world, constructed in an attempt to protect the tracks from becoming blocked with snow. Yet, snow is plastered to both sides of the walls; it was blown from either end of the snowshed and was allowed in through the ventilators, where daylight can be seen at regularly spaced intervals. (Trezise.)

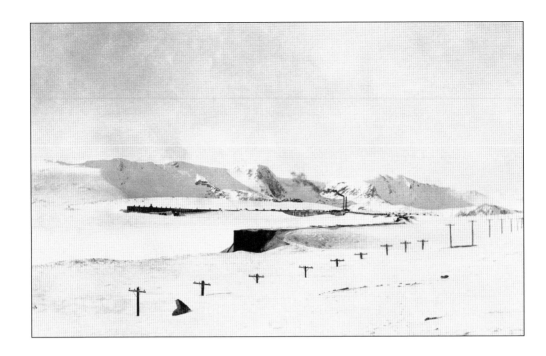

The railroad stop at the top of the world was a wooden complex, covered and accessed by snowsheds. The twin smokestacks of the power plant at Corona, built in 1915 or 1916, can be seen in the image above. Below, due to heavy snowfall amounts, the ties cannot be seen, just two rails gently curving towards the yawning opening of a Corona Station snowshed. Snow accumulation, not only on Rollins Pass but also throughout Colorado, was a problem. The January 30, 1918, *Herald Democrat* states, "Reports to the state public utilities commission today were that thirty-seven railroad locomotives are stalled in mountain passes [throughout Colorado] by the heavy snow." (Both, Trezise.)

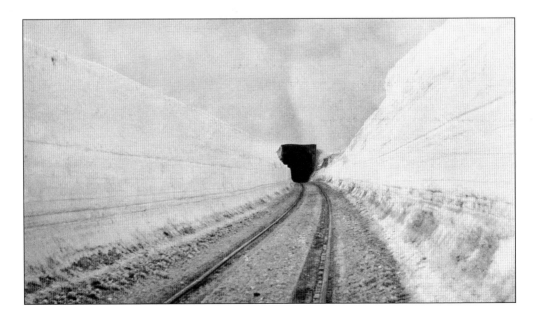

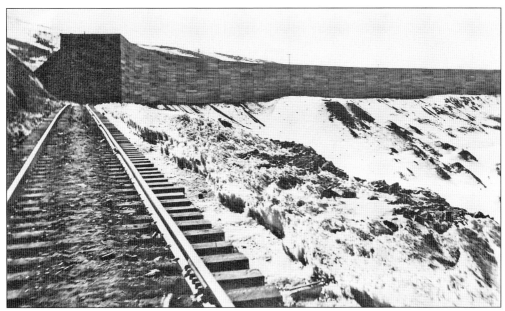

The thought was snowsheds should keep the tracks free of snow during the worst winter storms; unfortunately, Mother Nature found every weakness and blew snow between the cracks of the wooden planks, necessitating even further snow removal. The conditions within the snowsheds caused railroad workers to fall unconscious due to the belching smokestacks of waiting trains. The workers were carried to fresh air to recover. (GHS.)

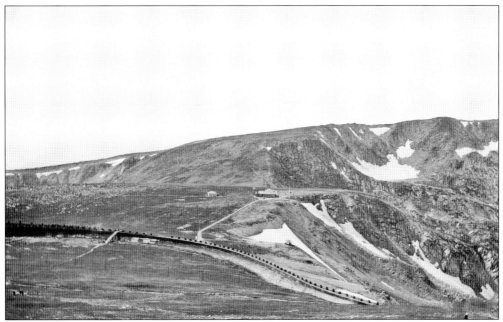

A snowshed with vents placed every few feet cambers over the summit. The railroad continually experimented with various vent designs, and per ICC Valuation Structure Notes, at least 15 different vent types were used throughout the railroad's existence. Early type "A" vents were five feet high; later, vents would receive extensions to rise above the 30-foot snowdrifts that can—and did—occur near the summit. (USFS.)

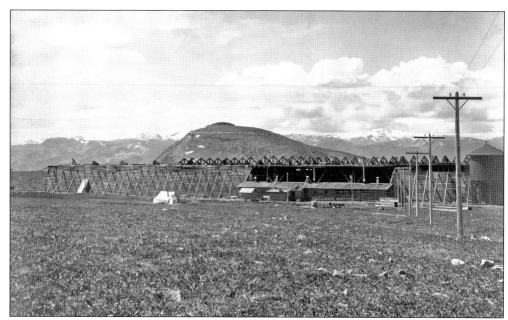

Snowsheds near the summit of Rollins Pass are dwarfed by the sprawling triangular back of Mount Epworth. This mountain, at times, is referred to as Pumphouse Peak. Each summer for the past half century, the Epworth Cup has drawn friendly competition among skiers. To the right of Mount Epworth in the distance, Byers Peak rises from the Fraser Valley floor. (GCHA.)

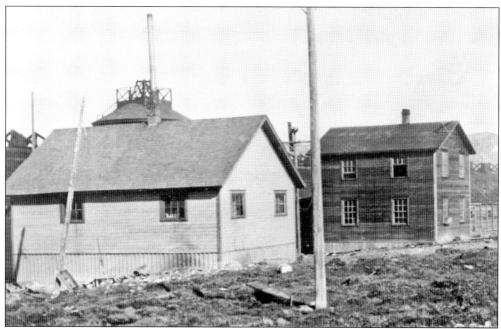

Corona on Rollins Pass was more than snowsheds, a restaurant, and a café. Living quarters and a hotel also existed at the summit. This photograph was taken facing the northwest and an overview of the complex itself can be seen on the top of the next page, where these two buildings are found at center immediately before the snowshed. (GCHA.)

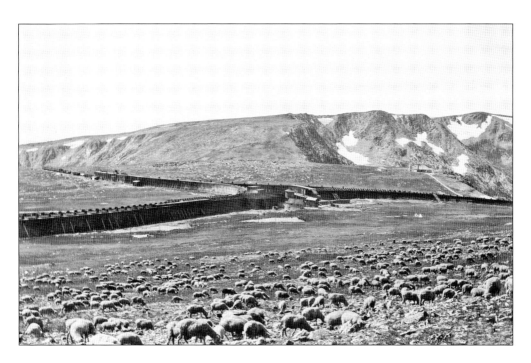

Sheep belonging to William R. Young graze in the warm summer sun at more than 11,677 feet above sea level in these 1917 photographs. The Corona wye (a track feature used for turning services) shows a train at the end of one of the tail tracks to the left of the scene. The Corona dining hall is towards the right; an optical illusion appears to have the dining hall at the base of the rock cliffs. Also of note are the two white triangular tents in the right center of the image. Below is a close-up photograph of these tents and their occupants, who flank a dog rolling in the grass. (Both, USFS.)

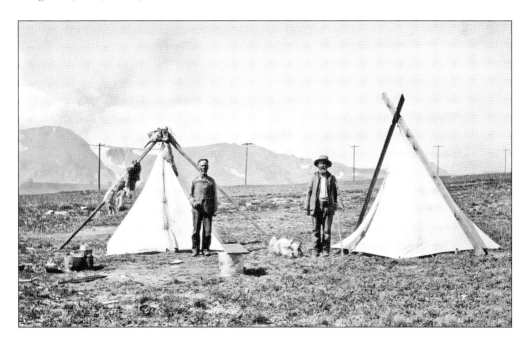

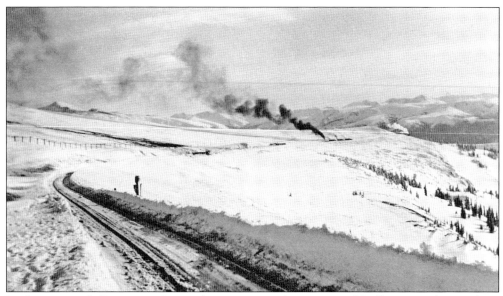

Looking towards Ptarmigan Point, this view near the summit of Rollins Pass shows a long train moving towards the summit. At left, a long string of telegraph poles is seen running parallel to the tracks. A close-up view of these telegraph poles can be seen at the bottom of page 100. (Trezise.)

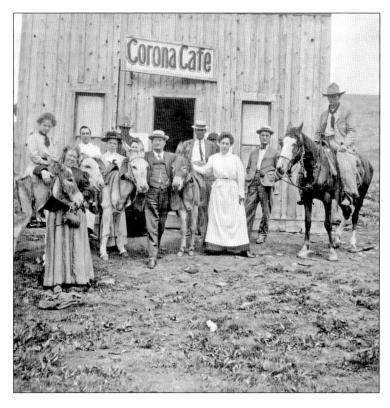

Fragments of dinnerwares professionally excavated at archaeological sites reveal an interesting commonality that holds true not just for Rollins Pass but on other sites as well: decorated plates, containing flowers or other designs, generally indicate a female presence in the settlement or camp. Male-only camps usually had plain or solid-colored dishware. (MNWC.)

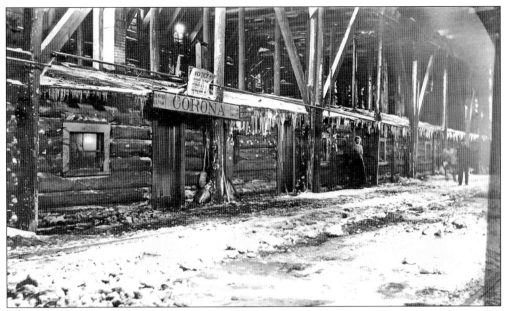

These are interior and exterior views of the snowsheds at the summit of Rollins Pass. Above, the station inside the snowshed reveals a sign for a telegraph office and impressive indoor icicles. Below, atop the large water tank in the center of the photograph, are components of the US Weather Bureau's observation station, including an anemometer. The prevailing wind direction was west, the lowest temperature recorded was -30 degrees Fahrenheit (in February 1910), and the most monthly snowfall was in March 1912 with 72.5 inches of snow. A small black smokestack to the immediate right of the water tower can be seen. This was the old Corona power plant, the roof of which is completely buried in snow. (Above, MNWC; below, Denver Public Library, Western History Collection, Call MCC-625.)

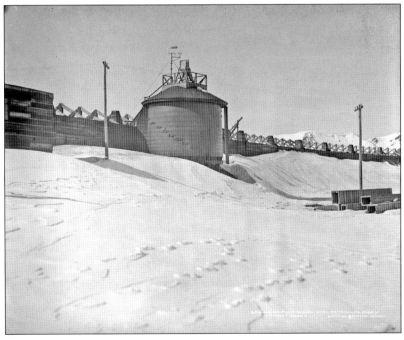

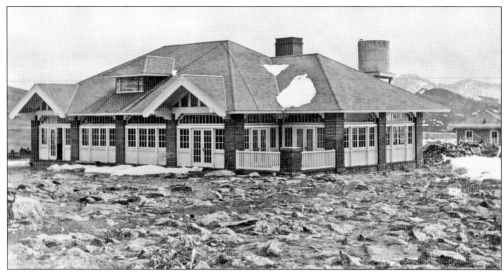

A photograph of the dining hall at the summit of Rollins Pass shows the outdoor patio that presented a panoramic spectacle with sweeping views from northwest through northeast. It also provides a clear look at the incredible number of windows this structure had to offer guests—even the transoms are paned with glass. A water tower, attached to the building, gave the cooks and the patrons water pressure, as there was no uphill from here. A second, larger chimney can be seen, which was used to vent a fireplace for guests, as the interior scene captured on a postcard, below, reveals. Many familiar with this building's ruins are aware that the brick was red; however, the roofing shingles were painted green. Green paint was used frequently in the early 1900s as it was easy to produce and resistant to fading. (Both, GCHA.)

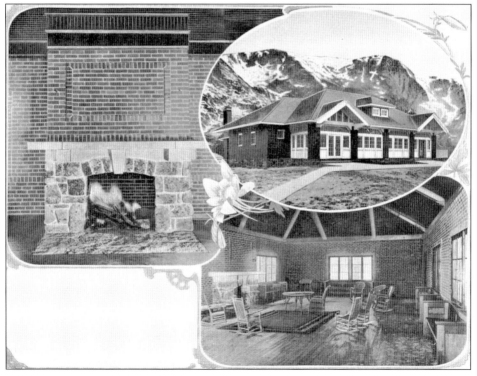

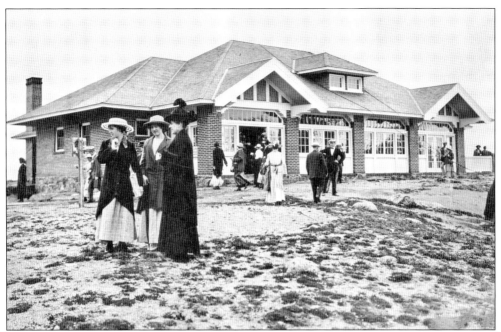

The dining hall at Corona Station was always open to feed weary travelers and railroad workers—at two different rate structures. Workers paid half price, and the cost of the meal was deducted from the next paycheck. According to records written by engineers and fireman who ate in the dining hall, beefsteak was the most popular dish, as it was reasonable in price yet high in protein. (USFS.)

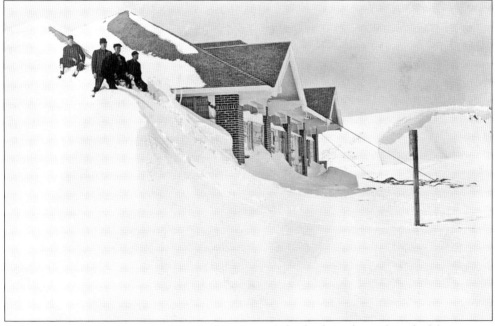

Tightly strung guy wires over the dining hall at Corona helped to keep the roof attached during gusts and gales; fierce winds deposited significant snowdrifts against this building, where the men can be seen at roof level, near the restroom. At the opposite end of the building, an outdoor summer patio had a splendid view of a cornice-laden bowl encircling King Lake in the distance. (USFS.)

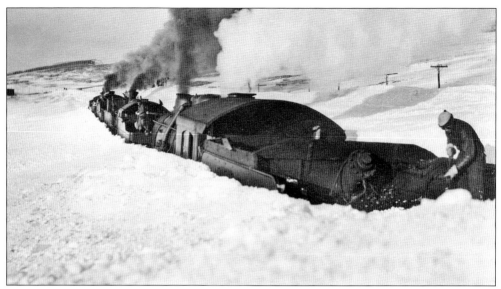

Several years after the railroad was in operation, mallets received a major upgrade in technology. A "superheater" was added, and this dried steam into a moisture-free pressurized gas, dubbed "dry steam." With this advancement, mankind mastered steam engine technology, and while this increased maintenance overhead, superheaters were far more efficient with how water and coal were used. (Trezise.)

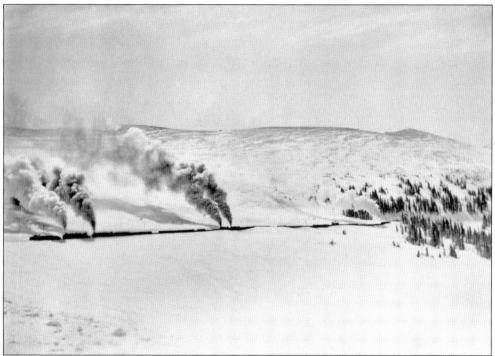

Firemen found a delicate balance between shoveling coal and avoiding weakening the motive power generated by the engine. They would throw in a shovelful of coal and slam the door shut; if too much cold air got inside, it would lower the steam pressure. In 1926, mechanical stokers automated the process of shoveling coal, delivering even more power. (Trezise.)

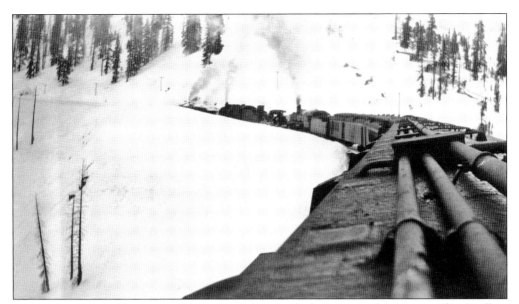

A passenger train with a rotary clears snow as it ascends the Loop on the western side of Rollins Pass. Numerous sources estimate more than 40 percent of operating expenses went towards snow removal. At the center of the photograph is the snow-covered entrance for Rogers Pass, with hiking trails leading towards Berthoud Pass along Heartbeat, James, Bancroft, Parry, Eva, Witter, and Flora mountains. (GCHA.)

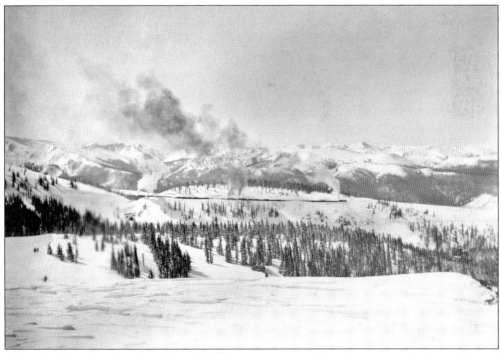

A famed railroad worker, Rev. Edward Bollinger, commented that the snow at the Loop, pictured here, could be as deep as 45–50 feet. Other workers relate they would back the train down to Ranch Creek to refill water—sometimes two or three times before the Loop was cleared of snow. (Trezise.)

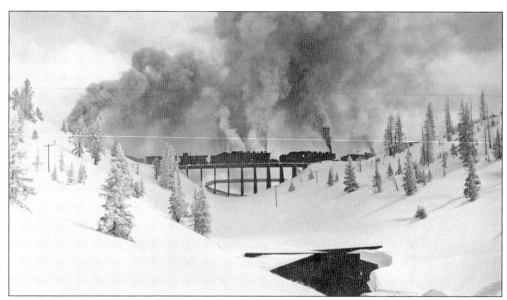

Engines moving uphill, from left to right, cross the Riflesight Notch Trestle. The top of the wooden western portal of Tunnel No. 33 can be seen at the bottom of the photograph. The Riflesight Notch area is so named because where the two hills converge, under the trestle, it appears as if one is looking down the barrel of a rifle and seeing the notch at the far end. (Trezise.)

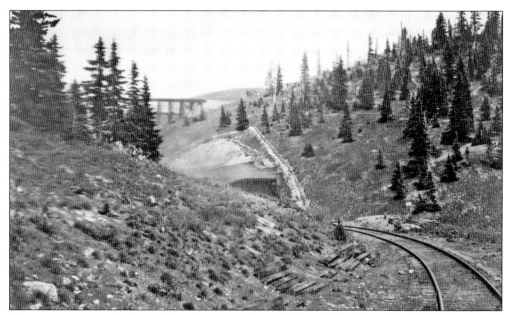

A passenger on a train in motion takes a snapshot of Tunnel No. 33 and the Riflesight Notch, or Loop, Trestle. The small white sign to the right reads, "Tunnel 33" and is placed such that downhill trains see the sign before entering the 412-foot-long tunnel. Later, 778 feet of snowshed would be added before the tunnel and 110 feet after to serve as a structural defense against avalanches. (GCHA.)

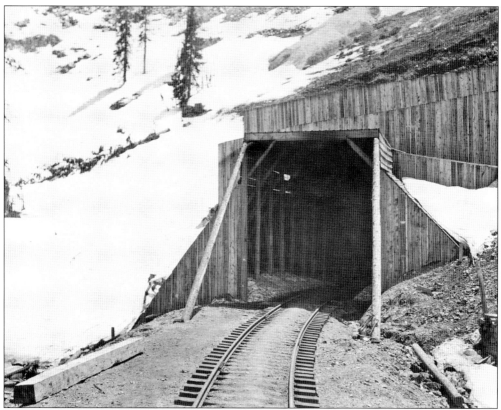

This is the east portal of Tunnel No. 33, under Riflesight Notch Trestle. This was part of Sumner's genius as chief engineer: devise a method using as much of the natural landscape as possible to gain or lose elevation (depending on the direction of travel). The elegance is classic Rollins Pass—perch a trestle perpendicularly atop a tunnel. (GCHA.)

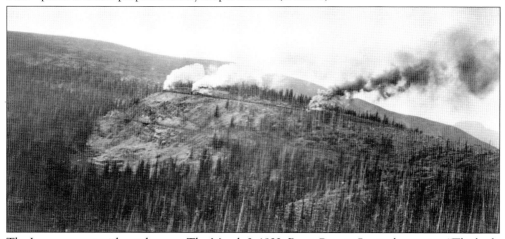

The Loop was not without dangers. The March 3, 1922, *Routt County Sentinel* was grim: "The body of Assistant Roadmaster Paul Paulson, who with three other Moffat road employes [*sic*] was killed Feb. [19]18 by a snowslide near the Loop, was recovered Saturday, and that of Section Foreman George Morganis was taken out of the snow Monday. The bodies of the other two section men were recovered last week." (GCHA.)

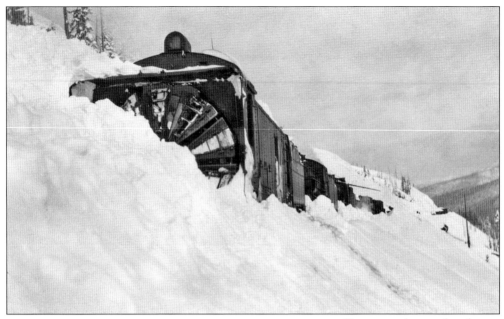

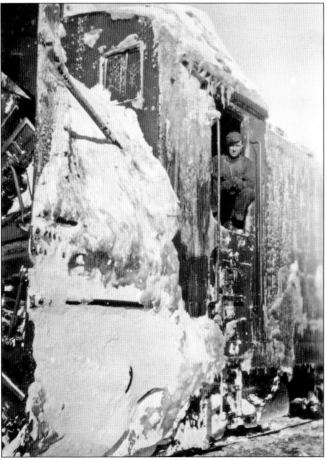

Days turned to weeks when Rollins Pass was blocked by snow, despite the use of rotary equipment. Period newspapers regularly note blockades lasting weeks; these frozen impediments required the railroad to stock extra provisions aboard trains. There was also frustration with first- and second-class mail held up in the blockades. "Why not then after 48 hours block of . . . Corona Pass send [mail] . . . by sleds?" a 1918 post in the *Routt County Republican* asked publicly. That same year, the *Oak Creek Times* had a front-page bulletin, "Only Four Pages This Issue: The Times this week consists of but four pages, due to the blockade on [Rollins Pass], which prevented the arrival of the ready-print from the Western Newspaper Union. We hope to issue a paper of regular size next Friday." (Both, Trezise.)

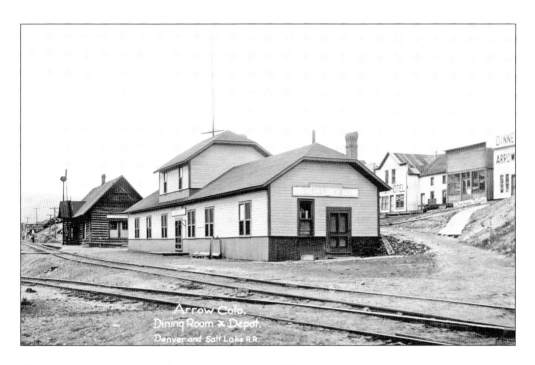

The town of Arrow bustled with more than 2,500 people, and the main street sported gas lamps—an amenity only seen in large cities such as Chicago, Illinois, at that point in time. In the photograph above, the lunchroom is in the foreground with the depot, a darker-shaded building, directly behind. Arrow was built around a wye to support the railroad efforts on Rollins Pass. Since wyes appear triangular and are shaped like arrowheads, the name took hold—Arrowhead, later shortened to Arrow. Arrow is truly a ghost town now. The main street has been lost to history, although there are a few graves nestled in a small grove of pine trees at the top of a hill overlooking the ski area at Winter Park. (Above, MNWC; below, GCHA.)

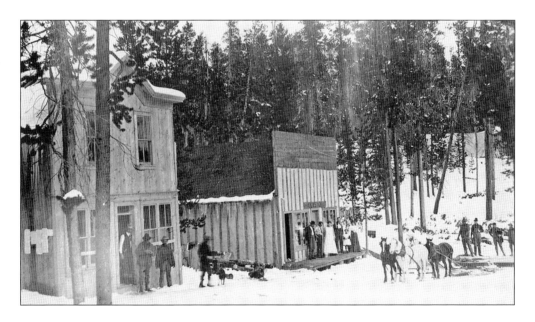

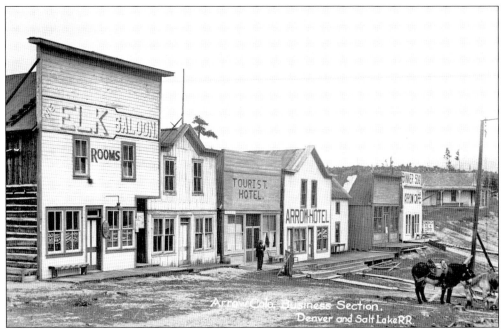

The main street of Arrow, seen in this view overlooking Middle Park on the west side of Rollins Pass, reflects an advanced frontier town. Arrow had at least 11 saloons as well as cafés, restaurants, several hotels, a post office, a schoolhouse, a grocery store or commissary, loading facilities, a pharmacy, four sawmills, a stockyard, and other buildings, including homes. The Elk Saloon, pictured above, was owned by Mart Wolf, who set fire to his establishment in hopes of collecting an insurance payout of $1,000. Unfortunately, the fire quickly spread, and Arrow was almost all but snuffed out of existence. (Above, MNWC; below, GCHA.)

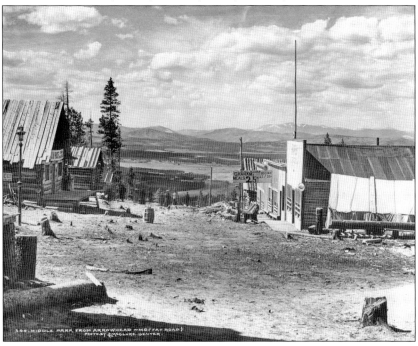

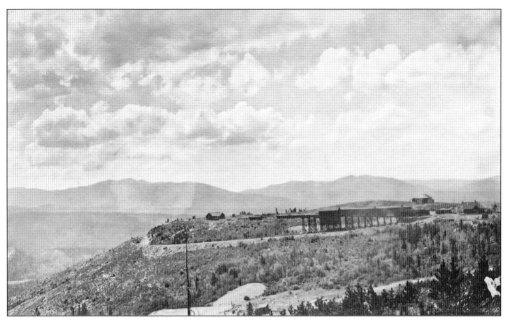

Following the fire at Arrow in 1915, very few buildings remained. This photograph, taken by Idellia Bumgarten sometime between 1923 and 1927, reveals railroad buildings and a lone house. These structures, including the trestle seen at right, eventually disappeared too, after the Moffat Tunnel was opened in 1928. (GCHA.)

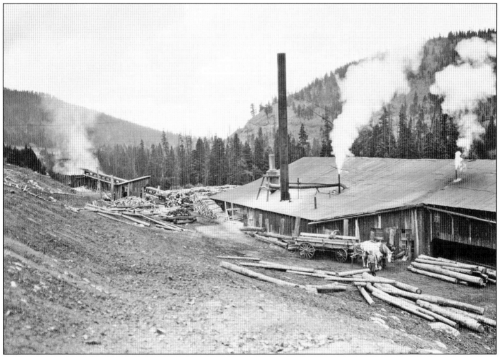

The sawmill yards at Irving Spur were located in the heart of "Old Town" Winter Park; it was a sprawling operation as seen in this photograph with piles of timber stacked behind the building. The initial grade up the west side of Rollins Pass can be seen at right. (USFS.)

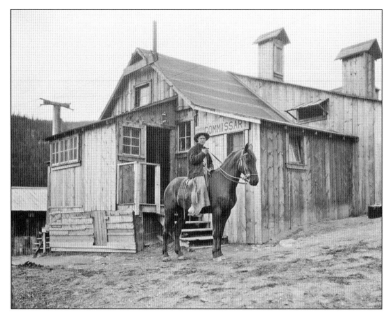

Sawmill and commissary owner W.H. Smith, president of the Wood Sawmill Company, pauses for a photograph on the back of a horse in front of his businesses. The sawmill provided milled lumber as well as rail ties to aid in the expansion of the railroad throughout Colorado. (USFS.)

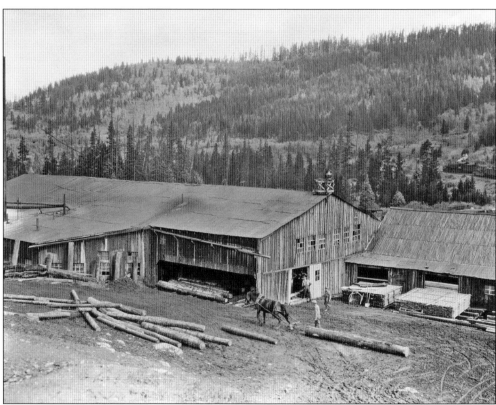

The lumberyard and sawmill at Irving Spur represented the first stop on the Rollins Pass rail line for trains moving over the Continental Divide towards Denver. At extreme right in this 1923 image, a train begins the climb back to Denver. These snapshots are all that exist today of the sawmill complex. (USFS.)

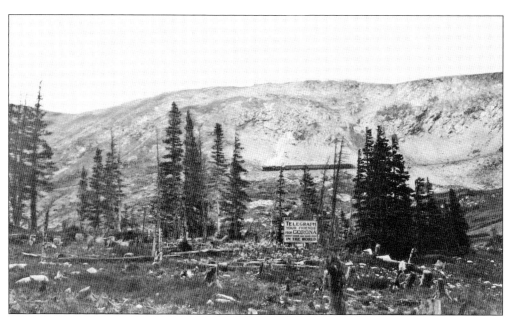

This billboard, placed near Jenny Lake, was used to excite tourists as they neared the summit: "Telegraph your friends from Corona | Highest standard gauge railway station in the world." This photograph serves as an advertisement within an advertisement. In the center of the frame, a train pulling three passenger cars can be seen working its way down the mountain, heading back towards Denver. Newspaper magnate Frederick Bonfils was the marketing genius behind Moffat's brochures and campaigns that ensured tourists traveled to Rollins Pass. It was Bonfils who coined the "Top of the World" and "From Winter's Snows to Summer's Glow" catchphrases. Below, to attract attention, Bonfils had a refrigerated car carrying snow from Rollins Pass delivered to a street in downtown Denver where ladies in swimwear posed on the frozen advertisement. (Above, GCHA; below, MNWC.)

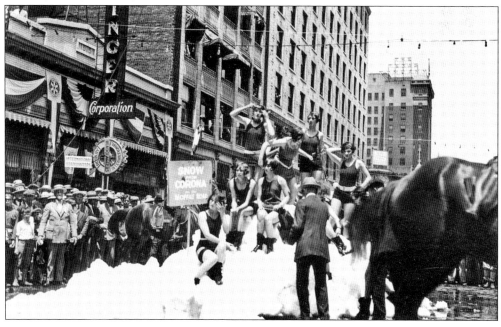

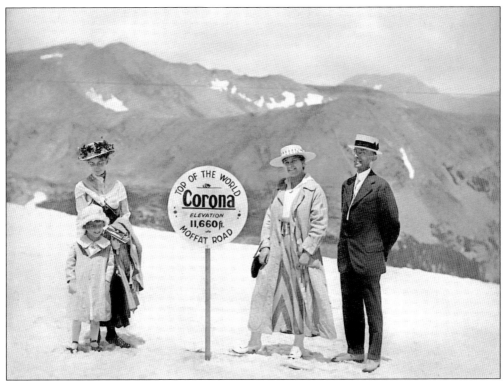

Tourists stand with the iconic "Top of the World" sign at the summit of Rollins Pass. Exuberant tourists would later write into newspapers of their excursions. One quote in the *Steamboat Pilot* newspaper reads, "Mr. and Mrs. M.W. Terry . . . were delighted with this section of Colorado and declared that the trip over [Rollins Pass] beat anything in scenery anywhere in the United States." (MNWC.)

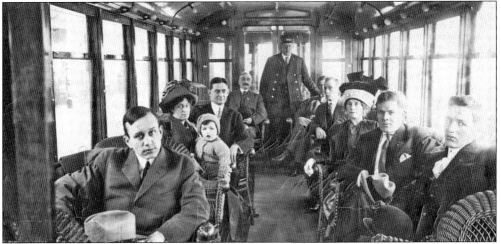

The *Middle Park Times* on June 11, 1915, published a heartwarming story: "Snowbound in June was the unique experience of a party of seventy-five tourists from Chicago, New York and Washington, who left Denver Saturday morning for a trip over [Rollins Pass] and who spent all of Saturday night dancing to the music of a phonograph in a rough log station on the mountain slope." (GCHA.)

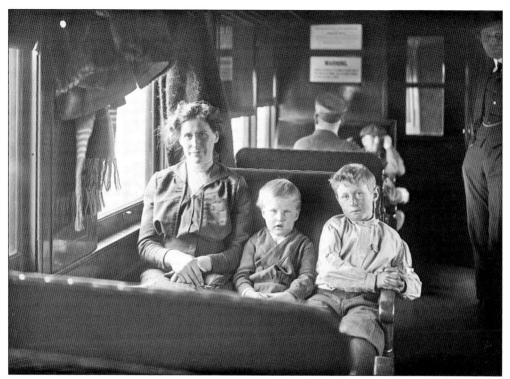

In the Letters to the Editor in the *Steamboat Pilot*, decades after Rollins Pass was shuttered to trains, George Barnes, the legendary conductor, was still remembered fondly for being extraordinarily helpful to passengers. When a train became stuck for three days, a passenger from Long Beach, California, wrote, "[He] did everything in his power to make us comfortable. I have not, and never can, forget his great kindness to us and patience with us and our children during that very trying time." Below, an aged Doc Susie (Susan Anderson, MD), is one of the more famous passengers to have ridden the rails over Rollins Pass. She expertly served both people and animals of Grand County for decades. (Both, GCHA.)

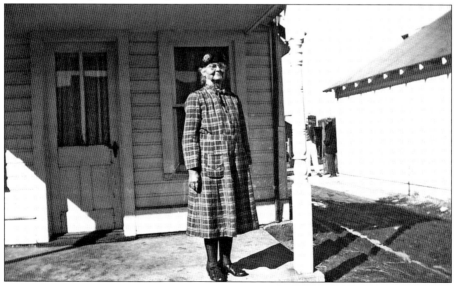

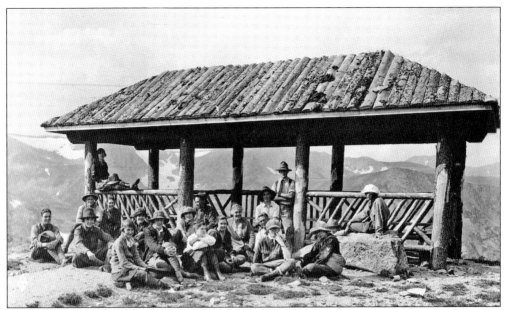

The Rocky Mountain Climbers Club rests at the pergola built sometime after 1913; small remnants of the roof can be found at the summit's easternmost point but much has succumbed to the elements or fallen downslope. The view from this porch on the eternal divide is timeless. Indeed, not too far from this area, many 21st-century graves overlooking Indian Peaks, the South Fork of the Middle Boulder Creek, and King Lake, have appeared. Below, in 1920, the climbers stand in deep snowfields near the railroad line itself. The cirque, in the distance, surrounds Corona Lake. Generally, these massive snowfields survive the intense summer sun until late July. (Both, Boulder Historical Society Collection of the Carnegie Branch Library for Local History.)

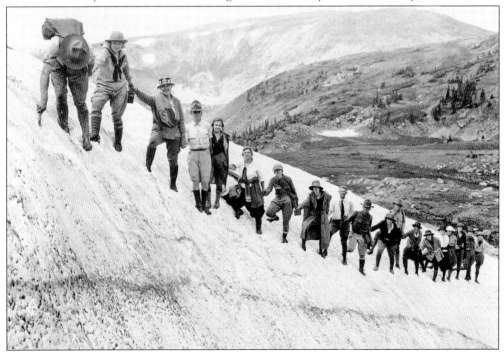

The Rocky Mountain Climbers Club pauses for a photograph in 1920 at a snowshed near the summit of Rollins Pass. The hiker sitting atop the snowshed confirms the sheer size and scale of the structure. Today, snowshed timbers, snowshed roofing, and occasional railroad ties are strewn downslope on the alpine tundra. (Boulder Historical Society Collection of the Carnegie Branch Library for Local History.)

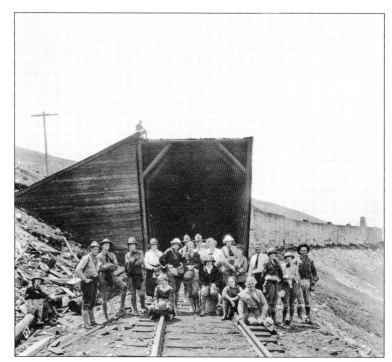

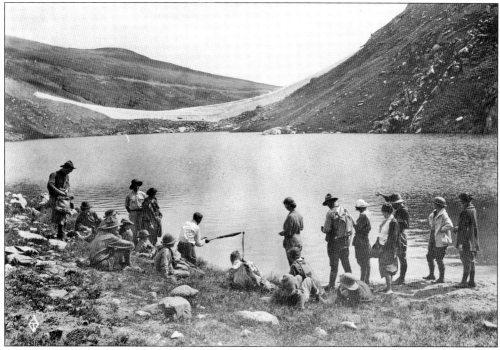

In 1920, the Rocky Mountain Climbers Club recreate on the shores of Pumphouse Lake. Mount Epworth rises from the western side of the lake; to the upper left and center, the cut made for the railroad grade can be seen. Satellite imagery of this area reveals fading wagon road tracks skirting the lake, along with impressions from where pump house pipes once stretched to the summit. (Boulder Historical Society Collection of the Carnegie Branch Library for Local History.)

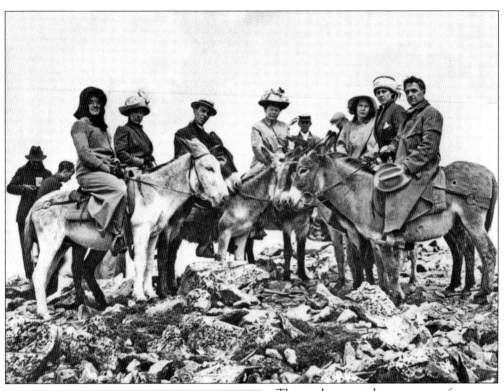

Those who wanted to see more of Rollins Pass on uneven ground would take donkey rides at the summit in the late summer months. Given the fierce winds that would blow on Rollins Pass, tour guides would charge extra for the retrieval of hats blown from the heads of patrons. Of interesting note, the women are not riding sidesaddle, which is atypical of the times. (GCHA.)

The Moffat Road had special Christmas offers. For example, the *Middle Park Times* advertised that tickets were selling on December 22, 23, 24, 30, and 31, and the return leg of the round-trip must be taken before January 5, 1909. Similar promotions were offered in early July for Independence Day. (Trezise.)

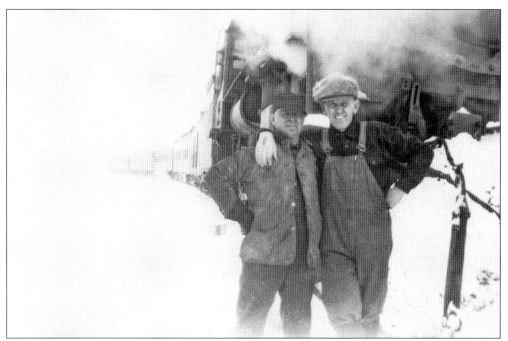

Written accounts of the railroad workers surprisingly do not mention the extreme and ever-present cold. The narratives reference the unbelievable amounts of snow; nonetheless, they all unanimously cite wind as the main obstacle to working on Rollins Pass. Indeed, hurricane-force winds regularly blow on Rollins Pass, confounding the plans made by even modern-day hikers. (Trezise.)

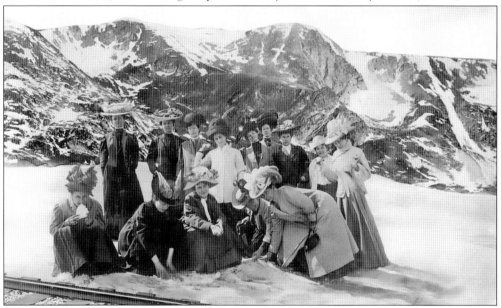

As with other period postcards, a cross made of snow can subtly be seen in the background. This iconography seems to be an early attempt at photograph manipulation as a cross does not appear naturally at this location in any season on Rollins Pass. Dr. Jason LaBelle wonders whether the cross was meant to tug at the heartstrings of religiously aware travelers who sought pristine, pure, and untouched lands above timberline. (LaBelle.)

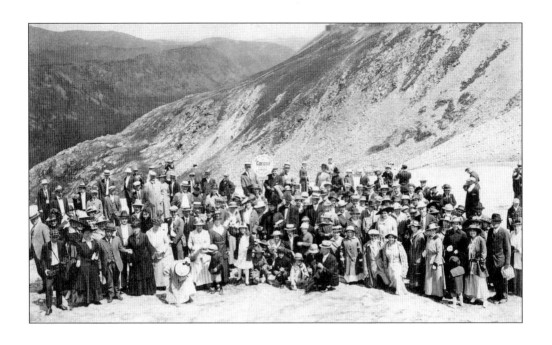

Summer tourists experience the thrill of Corona. Latin for "crown," Corona is located above King Lake—for the *king* wears a *crown*. The elevation of 11,660 feet shown on the sign in the middle of the group, above, reflects what might have been an original survey value obtained during either the late wagon road era or early railroad construction. A 1912 map shows 11,680 feet, but that is not based on a surveyed benchmarked location and was an estimated value based on nearby contours. The actual benchmarked survey elevation value of the summit of Rollins Pass is 11,671 feet (NGVD29), obtained during a 1952 second-order level line run from State Bridge to Denver by the US Coast and Geodetic Survey (predecessor to the National Geodetic Survey). When adjusted to NAVD88, the elevation is, without doubt, 11,676.79 feet. (Above, LaBelle; below, USFS.)

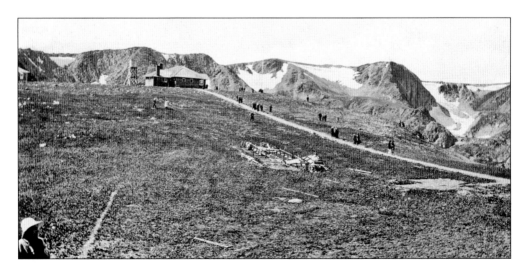

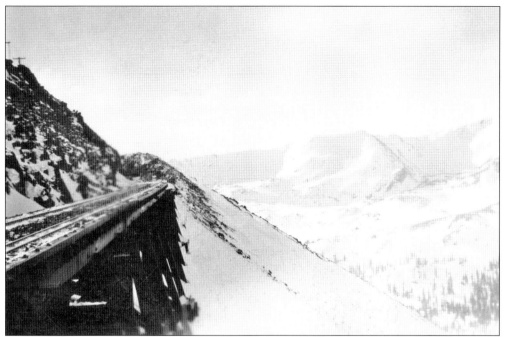

While automobile drivers would want a more robust guardrail, railroad guardrails run parallel to the existing track ensuring all wheels stay in alignment and do not leave the track—especially when on trestles. Guardrails assure adequate pressure is applied to the inside flange of the train wheel and are placed inside of the rail itself when on sharp curves or on steep drop-offs. (Trezise.)

Railroad workers referred to this majestic waterfall as Buttermilk Falls, affirming the phrase "They look like buttermilk, don't they?" No matter the name, they are as the railroad workers also exclaimed, an "unforgettable beauty." Snowmelt swells the falls in early July, and the roar of rushing water can be heard across the canyon. (GCHA.)

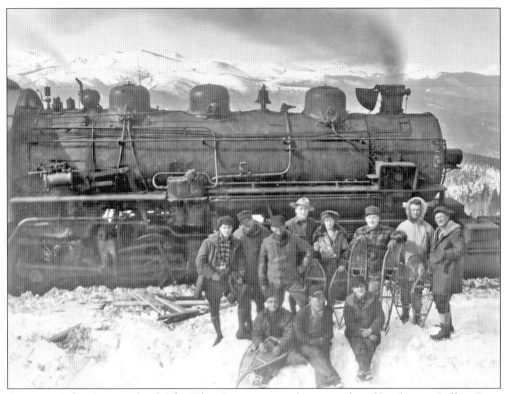

Courtney Ryley Cooper's book *The White Desert* was made into a silent film shot on Rollins Pass. The film was released on May 4, 1925, to help raise awareness (and funds) for the completion of the Moffat Tunnel. Reginald Barker was the producer and Claire Windsor, as Robinette, was the lead actress. Here, several members of the cast and crew pause for a photograph. (Cawker City Museum.)

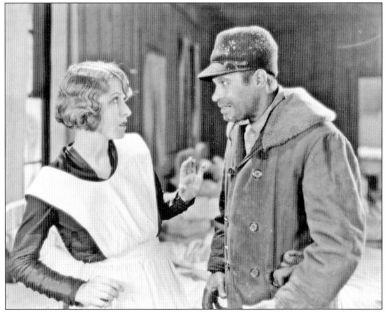

When Claire Windsor, the star of *The White Desert*, arrived on Rollins Pass, she was the only actress or actor who came prepared with snowshoes, mittens, and warm clothing. Windsor's stardom in the film led her to be crowned "Queen of the Denver Auto Show" in 1928, the year the Moffat Tunnel was opened. (Cawker City Museum.)

Workers on Rollins Pass railed against the Eighteenth Amendment. Stories shared by railroad workers talk of moonshine created at numerous stops on Rollins Pass, or it was obtained from Fraser, in the valley below on the west side. Prior to the Prohibition years, it was not uncommon for whiskey to be "lost" from rail manifests traveling over Rollins Pass. (GCHA.)

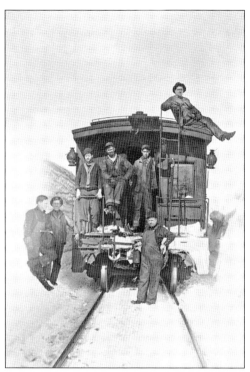

The eight-foot-long hand-hewn ties were composed of three distinct species—pine, oak, and walnut. When the rails over Rollins Pass were dismantled in 1936, materials were reclaimed and sold. Most ties below 10,000 feet were not reusable; overall, oak and walnut ties fared better. Workers toiled nonstop, including overnight, to remove the rails and ties. The west side was cleared by August 11 that same year; the east side, 14 days later. (GCHA.)

A full-depth avalanche thwarts passage on the tracks. Closest to the ground was a weak layer, likely comprised of sugary, cohesionless grains called depth hoar. The layer above—the slab—supported new snowfall. A wind-driven snowstorm rapidly loaded this lee slope (indicated by a cornice), causing the depth hoar to fail, resulting in a slab avalanche. Larger snow blockades could last days or sometimes several weeks. (Trezise.)

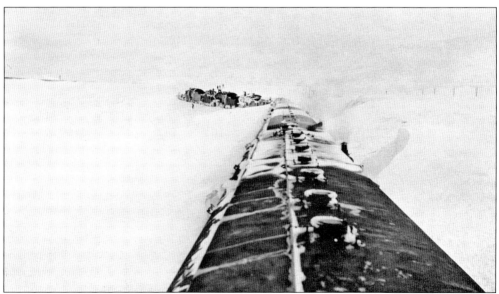

No matter the direction of travel, east or west, any train that stopped at Corona would undergo mandatory brake inspections. The railroad learned this lesson the hard way; many runaway trains on both sides of the pass resulted in lost time, damaged or lost equipment, and, most importantly, loss of life. However, over the quarter century the railroad was in operation over Rollins Pass, no passenger life was lost. (Trezise.)

According to Forest Crossen, a former railroad worker who labored on Rollins Pass, the maximum tonnage for a rail manifest on Rollins Pass was 1,910 tons (3.82 million pounds), the modern-day equivalent of the maximum takeoff weight of nearly four Boeing 747-8 airplanes. Later, manifests could tip the scales at 2,431 tons (4.86 million pounds). The rails upon Rollins Pass unquestionably took a beating. (Trezise.)

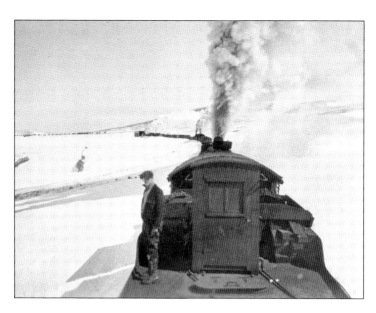

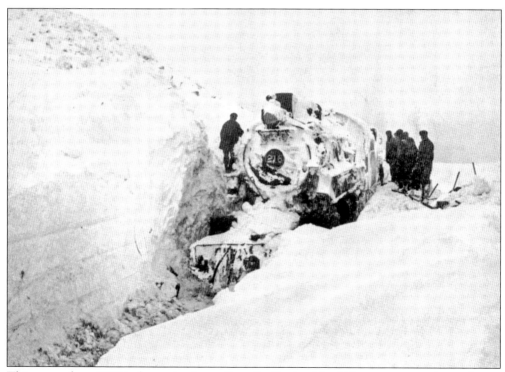

This scene from 1917 is frozen in time—literally. Engine No. 216 appears as an ice sculpture resembling a locomotive, more than the other way around. The workers in the photograph appear to have been working to dig out the engine, as evidenced by the shovel spade piercing the thick snow just below the smokebox. (GCHA.)

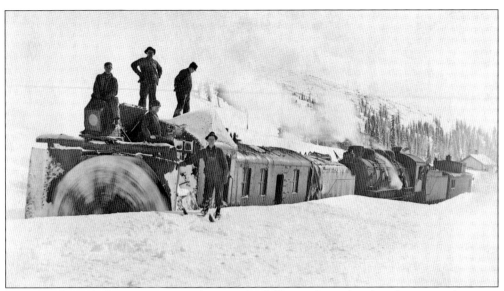

David Moffat took the unconventional approach of allowing his railroad workers to set their own contracts. This established a great deal of trust and camaraderie. After Moffat's death, tiered pay schedules were enforced to pay workers based on the equipment they operated as well as their seniority within the company. Class Three engineers (the most senior and the most experienced) were tasked to drive mallets up and down Rollins Pass. Per 1919 pay schedules, their wage was a comfortable $6.34 per day base pay (nearly $95 when adjusted for inflation), plus an additional $6.34 per mile. Considering that Lininger's Hotel at Arrow charged $30 per month, it is easy to see how this was a rewarding position. With high reward, though, comes considerable risk. The work was quite dangerous, and many died working on Rollins Pass. (Both, GCHA.)

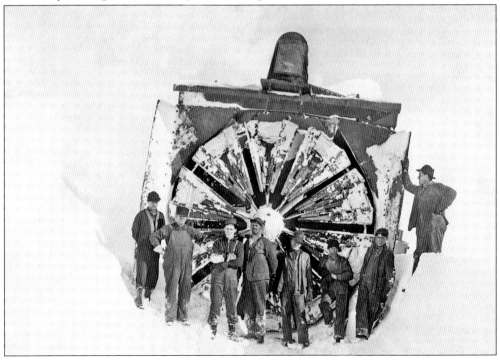

These astonishing and rare images show a rotary rounding the corner and parking on the smaller of the twin trestles that cling to the mountainside more than 1,000 feet above the ravine. At right, the component parts of a railroad trestle (from bottom to top) are as follows: the footer (or pier) is the actual rock of the mountainside, the mud sill—hidden by snow—serves as the base wooden foundation of the trestle, the posts are the vertical or mostly vertical pieces of wood, the sway braces are the wooden features placed at roughly 45-degree angles, the cap is the uppermost part of the supporting structure that lies flat, and the stringers are hidden but support the ties and track at the very top of the trestle. Below, men can be seen outside the windows of the rotary itself. (Both, Trezise.)

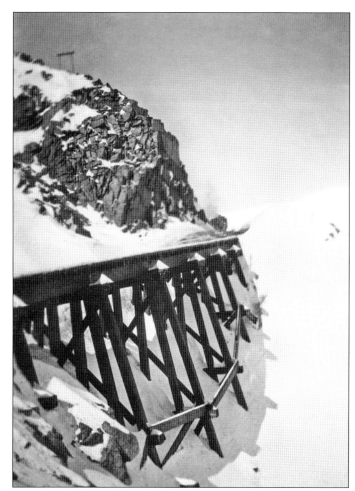

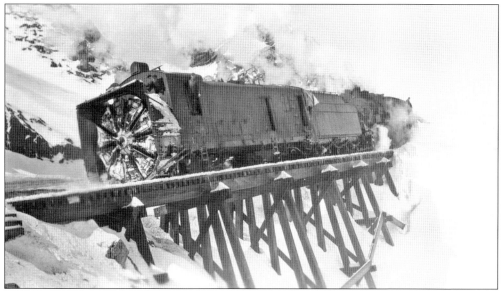

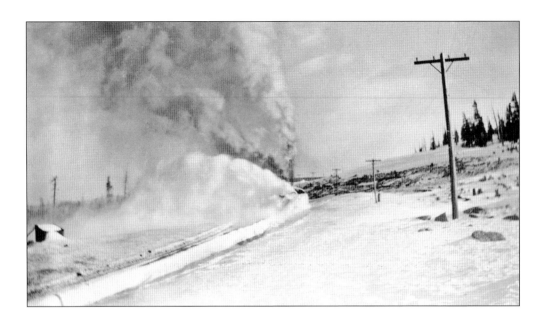

Above, a rotary snowplow projects a magnificent white arc of snow while the coal needed to power this high-altitude enterprise is burned, providing quite a show. Ironically, the rotary snowplow was first invented by a dentist, confirming the fears of many regarding the ambitions of those in the dental profession! In short, the rotary snowplow works similarly to regular residential snowplows used by many on their sidewalks and driveways. A large circular blade assembly in the front rotates at a high degree of speed, the blades cut through snow and ice, and once behind the blades, the processed snow is forced through a chute where it is tossed aside. Below, workers pause for a photograph as their equipment is topped off with water. (Above, Trezise; below, GCHA.)

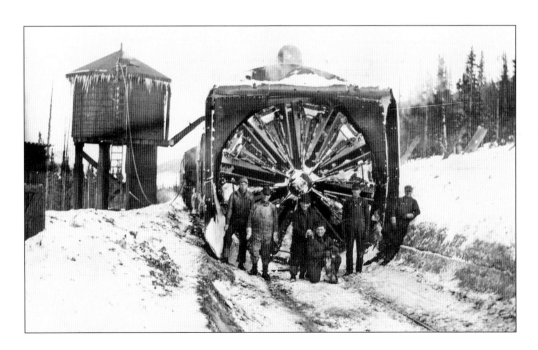

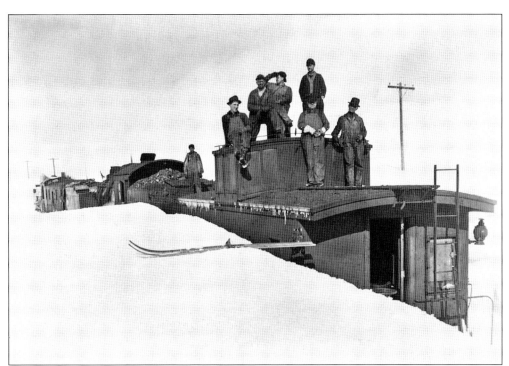

If a train became stuck due to snow or other mechanical issues, all components of the engine that held water or steam had to be completely drained so the engine would not freeze. If the workers failed to do so, expansion of the water in the valves would burst, rendering the engine disabled or completely unusable. (GCHA.)

Railroad fireman and engineer John Thomas Trezise is shown here at the summit with a snowshed in the background. Trezise was born on December 3, 1894, and later registered for World War I. He was honored in 1965 for his 50 years of railroading service. Trezise died in 1979, but his firsthand account of railroading on Rollins Pass lives on in his photograph collection and in the pages of this book. (Trezise.)

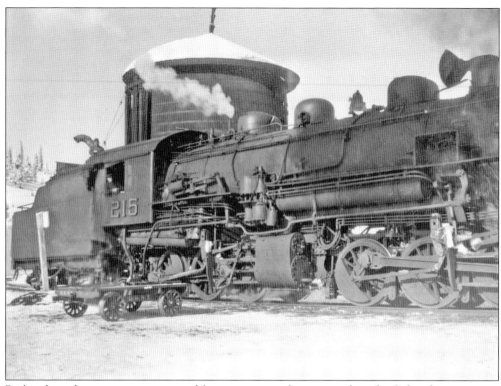

Railroad wrecks were an expensive and frustrating part of running rails in the Colorado mountains. This wreck happened the year before the rails were removed from Rollins Pass, and Trezise's photograph album documents the before (above) and after (below) disasters that can befall these behemoths. Per the Interstate Commerce Commission report on November 5, 1935, Engine No. 215 was a mallet compound locomotive of the 2-6-6-2 type, equipped with standard H6-ET air brake equipment, with two Westinghouse 8.5-inch cross-compound air compressors and two main reservoirs. The runaway started at the East Portal of the Moffat Tunnel, where the train rolled backwards at speeds of 60-plus miles per hour and all driving brake shoes had melted in a furious effort to stop the train before derailment at Rollinsville. Wrecks happened throughout the years Rollins Pass operated as a railroad. (Both, Trezise.)

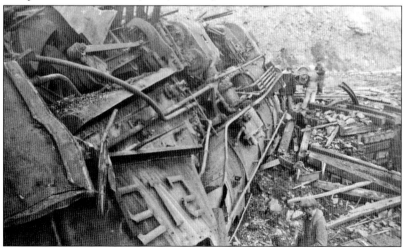

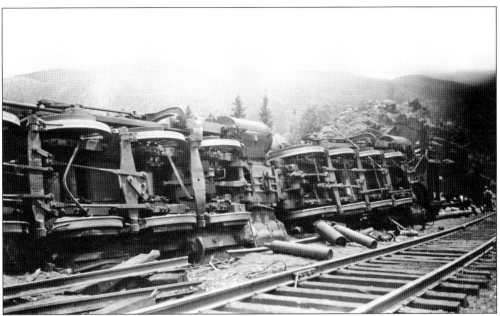

An article in the *Steamboat Pilot* is illustrative of why legends abound of Moffat's men toiling on Rollins Pass: "When Engine 201 jumped the track in a runaway on the 'Top of the World' line over Corona [P]ass in the days before the Moffat tunnel, Mr. [George] Barnes re-railed the giant locomotive without the aid of a wrecker—for the simple reason that [there was no] wrecker." (Trezise.)

In addition to endless expenses and man-hours, construction of the Moffat Tunnel through James Peak, pictured here, required plenty of dynamite and electric power. More than 700 miles of drill holes were made to be filled with 1,100 tons (2.2 million pounds) of dynamite. At least 28 gigawatt hours of electricity were used in construction—enough to power 725,000 modern homes for 28 hours. (GCHA.)

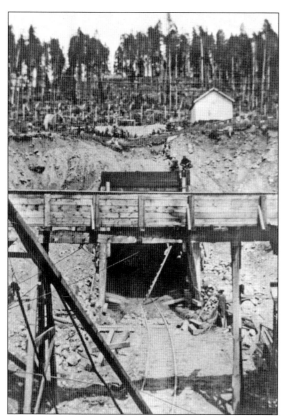

When asked to define the rock structure at the West Portal, the chief engineer said, "A hard biotite gneiss, broken by slickensided seams, slightly permeated with water, shot with feldspar." Upon hearing this description, workers said, "This sounded pretty good. The 'tite' part of 'biotite' was fine, 'Gneiss' being pronounced 'nice,' a little water hurts no man, and while we had never been shot with feldspar, we were not adverse [sic] to that sensation, so felt better." When workers examined the rock, their response was, "Soft and wet, all shot to hell." Indeed, workers encountered rocks so soft they could be excavated by hand. The Lewis traveling cantilever girder was later used. This held the weight and pressure exerted on the bore (more than six tons per square foot), ensuring that progress could continue without cave-ins. (Left, GCHA; below, Trezise.)

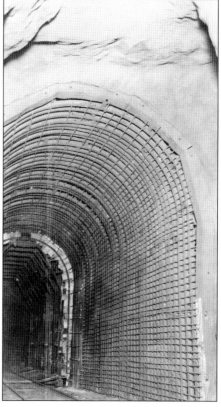

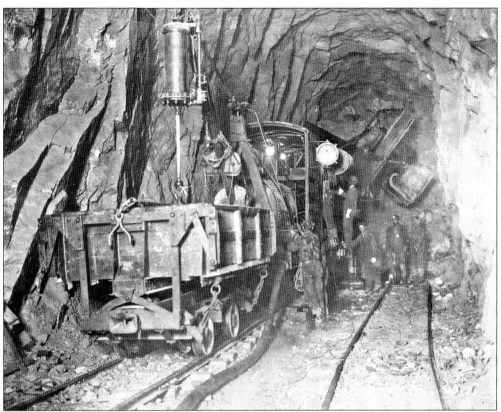

The Moffat Tunnel took five years to complete with workers toiling at both ends and meeting in the middle of James Peak. The project cost $24 million. Costlier, however, was the loss of human life; 28 men died. On July 30, 1926, seven men and a shift foreman were caught in a cave-in on the West Portal of the tunnel, killing six. (Boulder Historical Society Collection of the Carnegie Branch Library for Local History.)

A January 27, 1928, article in the *Steamboat Pilot* reads, "With the . . . [upcoming] completion of the Moffat [T]unnel the tracks will be abandoned 'over the hill' and . . . it will eliminate one of the noted summer trips of the state, the trip over Corona [P]ass. . . . Tourists may miss Corona, but the regular residents will be thankful that its rigors will no longer be a bar to progress and development." (GCHA.)

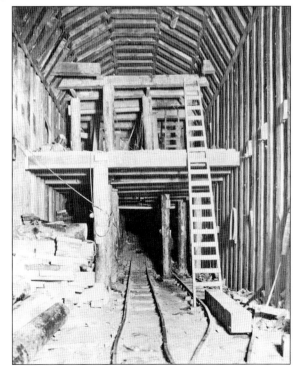

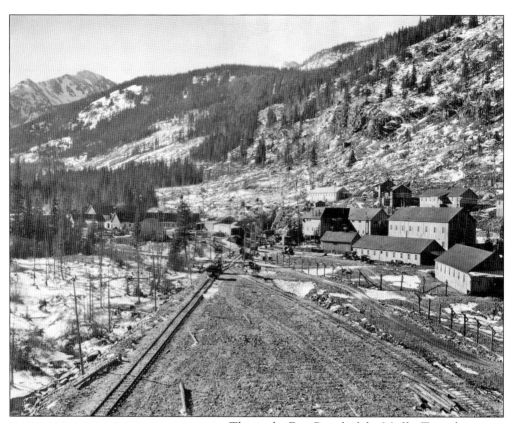

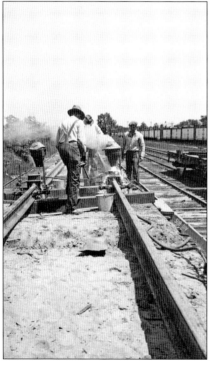

This is the East Portal of the Moffat Tunnel before the concrete face was erected. At left, segments of rail for the Moffat Tunnel are being aluminothermically welded together amid a shower of sparks. Aluminum powder and iron oxide are ignited inside of the crucible (above the rail, with the oversized funnel appearance). Due to exothermic chemical reactions at more than 3,625 degrees Fahrenheit, the iron oxide loses the oxygen molecules to become iron and the aluminum converts to alumina, becoming a lightweight slag that floats to the surface of the molten metal. This process fills the gap between the two rail segments and was patented in 1895. (Both, Boulder Historical Society Collection of the Carnegie Branch Library for Local History.)

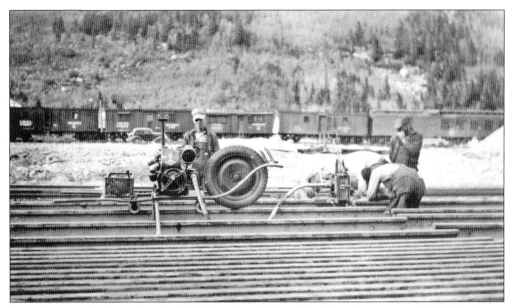

According to the December 9, 1927, *Steamboat Pilot*, railroad workers were scheduled to begin laying ties and tracks inside the Moffat Tunnel, a task estimated to be completed within two weeks. Here, workers can be seen preparing rows of rails. (Boulder Historical Society Collection of the Carnegie Branch Library for Local History.)

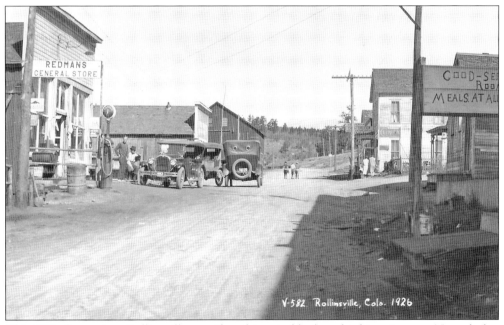

This 1926 glimpse into Rollinsville provides a historical look at this historic town. Named after John Quincy Adams Rollins, this town originally appeared on maps with its first stagecoach stop in 1862 and has had an operating post office since 1871. The 2010 census indicated a population of 181. (GHS.)

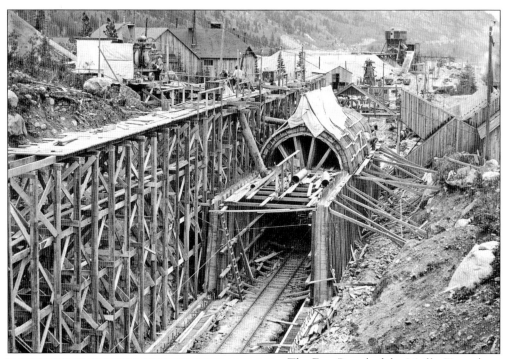

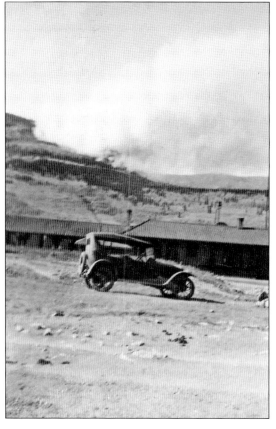

The East Portal of the Moffat Tunnel is larger than the West Portal because it houses a massive ventilation plant with blowers that moved up to 420,000 cubic feet of air per minute. Westbound trains have their exhausts ventilated out the east side; eastbound trains have their exhausts vented through the West Portal. For either instance, the East Portal blowers are used. (MNWC.)

This rare 1923 photograph shows a growing fire on Giant's Ladder on the eastern side of Rollins Pass. The fire, caused by a train engine, billows smoke. This same year, construction efforts began on the Moffat Tunnel. (GHS.)

To finish holing through James Peak, Pres. Calvin Coolidge remotely turned a key detonating a charge that explosively connected both ends of the tunnel. A separate cast was made for each ornamental bronze character on the East and West Portals of the tunnel, costing $40 per character. On each portal are the dates: 1923, when construction started, and 1927, the scheduled completion year. Despite the tunnel opening in 1928, it was decided not to change the dates on either portal, saving the commission $80. Today, this tunnel is used for both freight and passengers. Below, Moffat Tunnel commissioners and engineers, who accomplished the impossible, stand for a photograph. (Both, MNWC.)

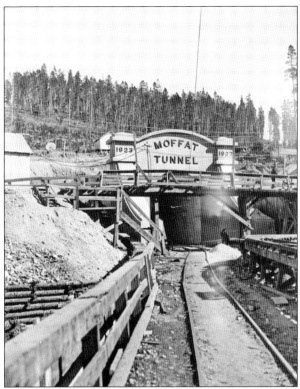

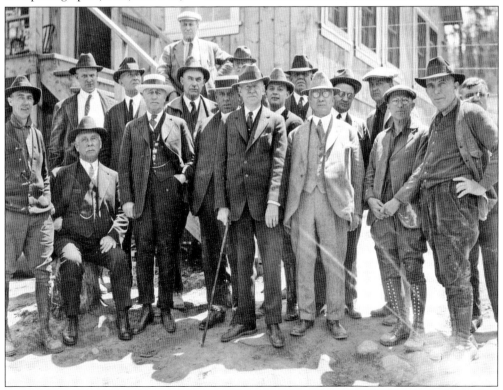

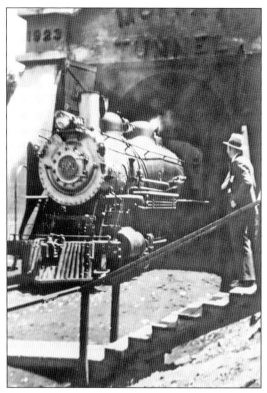

At left, the very first train exits the West Portal of the Moffat Tunnel, effectively signaling the end of sending trains up and over Rollins Pass, save for a few rare runs. Below, a train moves through the Moffat Tunnel, illuminated from the front to help film a scene for the movie *Trail of '98*. A March 9, 1928, article in the *Steamboat Pilot* carries a headline, "Top of the World Has Been Abandoned." The article mentions that the last two men, H.R. Jones, a telegraph operator, and A.J. Crockett, a lineman, had to remain at Corona to route telegraph messages "over the top" before telephone and telegraph lines were functioning in the Moffat Tunnel. The article ends, "Corona is abandoned. It goes without regrets." (Both, GCHA.)

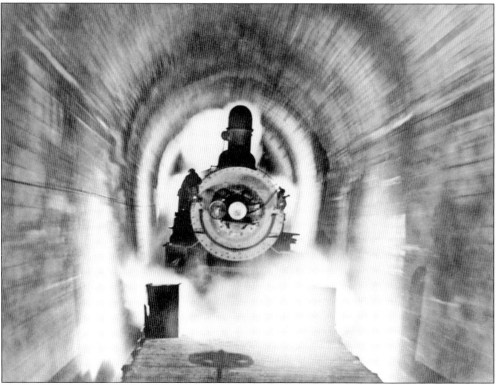

Four

DISREGARDED AND OVERLOOKED

1928–1956

The year penicillin was discovered, a faster course through the Rocky Mountains was finally opened. The circuitous Rollins Pass route—in optimal conditions—took approximately 150 minutes and was never meant to be permanent. When the Moffat Tunnel opened in 1928, despite the known parsimonious typographical error on the portals of each side of the tunnel, the Rollins Pass rail line began to fall into disrepair. It did not take long for the Moffat Tunnel to prove its reliability and expediency; the interior was weather agnostic, and the journey took 12 minutes in darkness to travel under the Continental Divide.

The rails and ties were cleared away from Rollins Pass in the summer and fall of 1936. Shortly thereafter, railroad-supporting structures were removed. The US Forest Service dismantled the dining hall at Corona and attempted on at least two occasions to burn the snowshed planking. The Bethell process, patented a century earlier, used coal-tar creosote to treat and preserve wood, which resisted the multiple burn attempts, leaving nature to break down the wood on her own schedule.

The roadbed was used as a primitive thoroughfare for light recreational use and as an access road for the Federal Aviation Administration (FAA) to service a rotating radio beacon used for aerial navigation near Rollins Pass. This beacon first appeared on aviation maps in 1948. The FAA removed the trestle at Ranch Creek Wye on the western side of Rollins Pass in 1953. Winter Park resident and innkeeper Dwight Miller had serendipitous timing, and his phone call to the US Forest Service saved the remaining trestles on Rollins Pass from meeting an explosive end.

Winter Park and the Fraser Valley were undergoing revitalization though labor provided by President Roosevelt's Civilian Conservation Corps, and the Winter Park Ski Area was beginning to appear on the map as a sensational recreational spot 90 minutes from Denver. Planting lodgepole pines, stocking the Fraser River with fish, constructing bridges, and skiing—all happened within view and under the shadow of what seemed like a forgotten Rollins Pass.

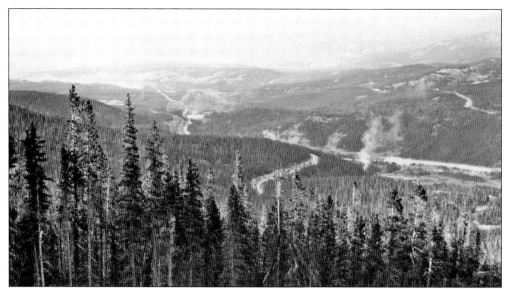

In October 1947, Fred Johnson captured this view of the lower western portion of Rollins Pass across the valley from the top of Balch Run, named for Robert Balch, at Winter Park Ski Area. A plume of smoke, perhaps from a passing train, can be seen at center. The towns of Fraser and Tabernash branch off the main road leading into the distance. (USFS.)

A view near Skyscraper Reservoir in the Roosevelt National Forest reveals a timeless crossroads on Rollins Pass—all represented in one photograph. Native Americans used this land as did the toll wagon road; Tunnel No. 32 can be seen at center left; and James Peak, housing the Moffat Tunnel, looms in the distance at left. This scene represents some of the best hiking on Rollins Pass. (USFS.)

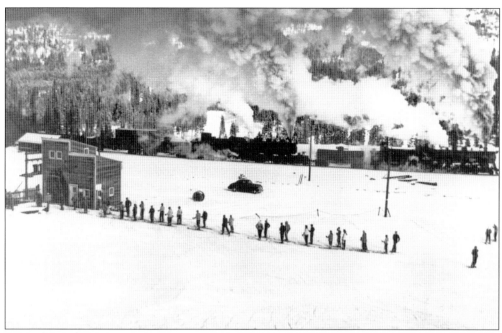

Trains began bringing more than cargo and tourists to Winter Park and the Fraser Valley—they started bringing skiers, too. The Winter Park Ski Area, opened in the winter of 1939–1940, has been serviced by trains for decades. This is suitably fitting as the resort is located at the West Portal of the Moffat Tunnel. (GCHA.)

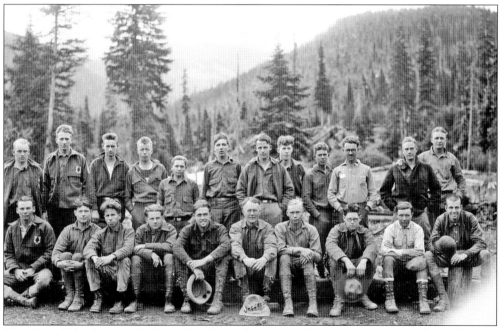

This incredible photograph shows handsome forestry students in training near Irving Spur in Winter Park, Colorado, led by Jeffers from Ames, Iowa. The Idlewild Ranger Station was located 200 yards away from the sawmill and presumably served as their base of operations during the training period. (USFS.)

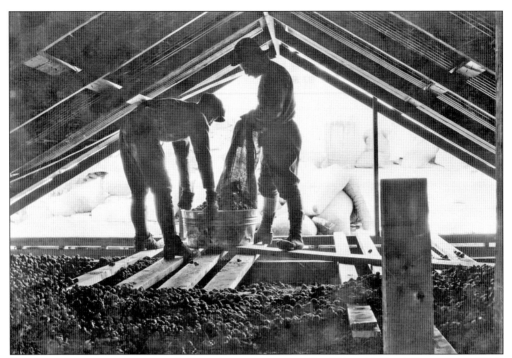

Forest rangers sort serotinous lodgepole pinecones in the Idlewild Seed Extractory. High temperatures, found in forest fires, are required to break open the resinous bond and release the seeds. Unfortunately, the recent epidemic of pine beetles in Grand County, Colorado, preyed upon many mature lodgepole pines planted from seeds extracted at this location. (USFS.)

Forest officers place fingerling rainbow trout into beaver dams on the Fraser River. The repurposed milk canisters in the photograph read, "US Bureau of Fisheries." In 1940, this bureau was combined, along with the Bureau of Biological Survey, into the modern-day US Fish and Wildlife Service. The hill in the background appears to be the western grade used to ascend Rollins Pass towards Denver. (USFS.)

The US Forest Service felled trees within the valley, above, and those trees lived a new, horizontal life as hiking bridges over streams and rivers in Grand County, as pictured below. Clear-cutting is often perceived as malevolent destruction rather than a planned and thoughtful renewal. Quaking aspen trees are shade intolerant and do not grow well under the canopy of dense pine forests; clear-cutting of pine trees helps diversify the forest by allowing aspen and other species to intermix with pine. Clear-cutting experiments are shown at the bottom of page 89; studies done in the Fraser Experimental Forest (FEF) definitively show that unmaintained forests result in slower growth and higher mortality than a forest that is more actively maintained through the use of clear-cutting. (Both, USFS.)

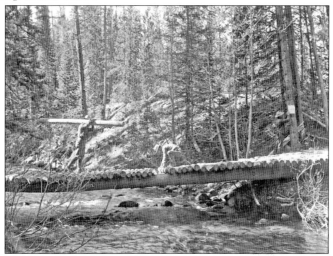

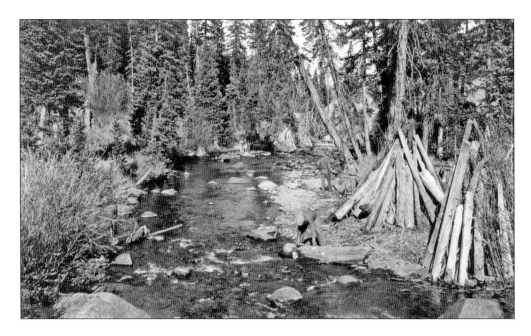

Civilian Conservation Corps (CCC) workers from Tabernash are performing stream improvement work, including removing driftwood and freeing logjams, on the Fraser River not too far from the West Portal of the Moffat Tunnel. The CCC program was established as part of President Roosevelt's New Deal, providing unskilled manual labor jobs to agencies related to public land conservation and development. The urgent need for manpower in World War II brought an end to the CCC; however, German prisoners of war resided in the Fraser Valley. Their compulsory volunteering was in similar capacities to the CCC workers. (Both, USFS.)

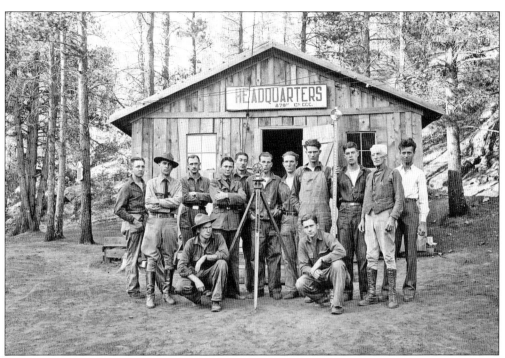

The CCC was founded in 1933. Overall, more than three billion trees were planted between 1933 and 1942 in addition to the construction of countless trails and lodges across America. Men from the age of 17 to 28, if unemployed and unmarried, were eligible to join the CCC for wages totaling $30 per month, of which $25 was required to be remitted to family at home. (USFS.)

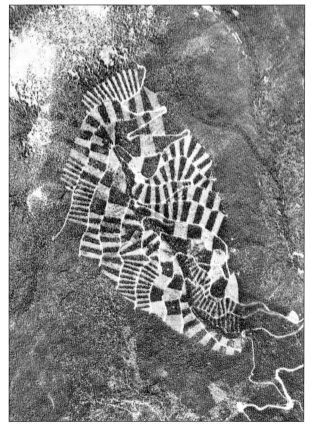

This view from the air reveals the intricacy of the Fraser Experimental Forest (FEF) project. The FEF was started in 1939 as part of a larger, national experimental forest network. Early studies helped researchers understand the relationships between forest management and water yield. The FEF now helps researchers understand forest mortality following the pine beetle epidemic and the interrelationships affecting water and nutrient cycles as well as forest regrowth. (USFS.)

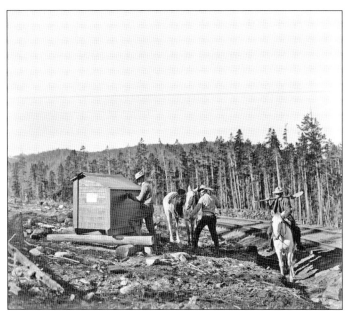

Forest rangers work in the forests bordering the railroad. The forest, particularly in the Fraser Valley, consists of Engelmann spruce and subalpine fir at higher elevations and close to streams; lodgepole pine at lower elevations; 200- to 400-year-old trees in virgin stands; second-growth lodgepole pines after forest fires or logging work; patches of aspen; and occasionally 450- to 500-year-old Douglas firs. (USFS.)

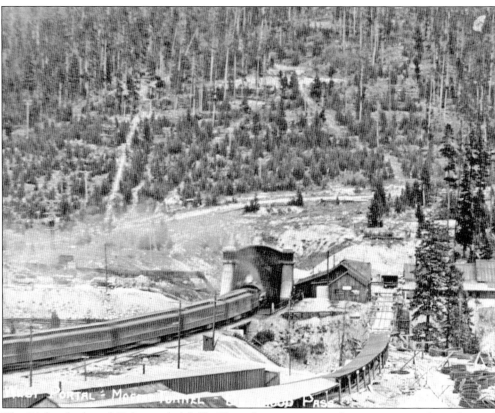

The 24-foot-high and 17-foot-wide Moffat Tunnel was constructed using a pioneer bore, located 75 feet to the right. The growing Front Range megalopolis in Colorado needed water, so an innovative concept was born—convert the pioneer bore into a water tunnel, named the Moffat Water Tunnel, to funnel mountain water towards Denver. (GCHA.)

Power lines stand 50 feet apart on the mountains between Rollins Pass and Heartbeat Peak. Double crossarms, also known as storm spans, were added to make the power lines more resilient in squalls. These power lines stretched from the East Portal near Rollinsville to the West Portal near Winter Park, and many utility poles with clay insulators can still be found at higher elevations. (Courtesy of Denver Water.)

The men working the afternoon shift are preparing to enter the West Portal of the Moffat Water Tunnel. The pioneer bore needed to be expanded to 10.5 feet in diameter and reinforced with steel and concrete on the western slope side as it was a pressure tunnel (to pump water towards the apex); on the eastern side, it was an unlined gravity tunnel until the 1950s. (Courtesy of Denver Water.)

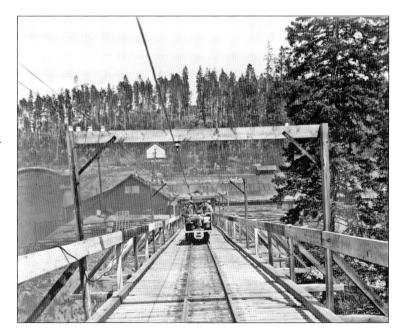

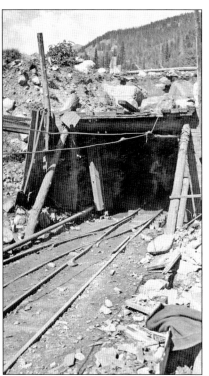

This is the East Portal of the Moffat Water Tunnel after the removal of construction snowsheds. From East Portal, the water empties into South Boulder Creek and travels downhill for 23 miles. The South Boulder Diversion Conduit picks up the flow and carries the water 9.7 miles to the Ralston Dam and Reservoir. From there, the water is diverted through various conduits into and around Denver. (Courtesy of Denver Water.)

Crews prepare to enter the Moffat Water Tunnel for enlargement work on August 20, 1935. The work here was just as grueling as it was during the construction of the Moffat Tunnel. Work was started in the early 1930s, and the first water flowed through the tunnel in 1936, increasing Denver's water supply by 30 percent. (Courtesy of Denver Water.)

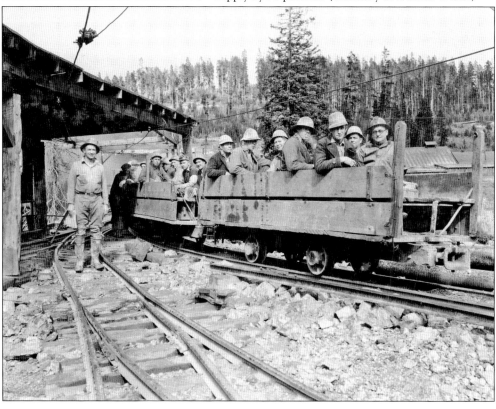

Despite the depth of early April snow near the West Portal, workers load electrically driven cars waiting on the industrial track with sand. Per Denver Water, the sand was "used in grout being placed back in liner plates" within the Moffat Water Tunnel. Based on 1937 figures, 102,000 acre-feet of water (33.24 billion gallons) flowed through this tunnel annually. (Courtesy of Denver Water.)

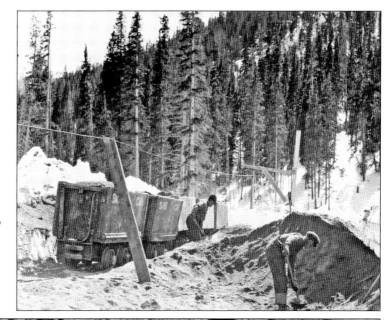

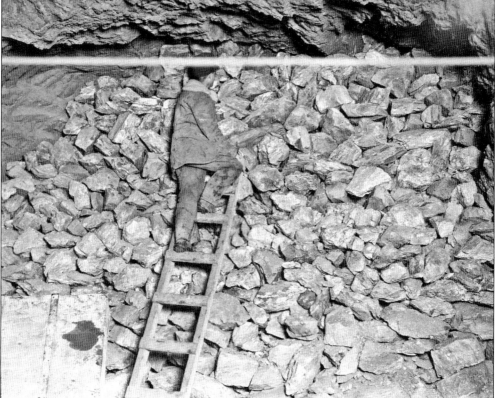

Following the removal of the air compressor in crosscut No. 4 West, rock packing between bulkheads was accomplished. The Moffat Water Tunnel has several wyes, or branches, accepting water from geographically separate sources inside the tunnel: Vasquez Creek, the Fraser River, Jim, Buck, and Ranch Creeks. (Courtesy of Denver Water.)

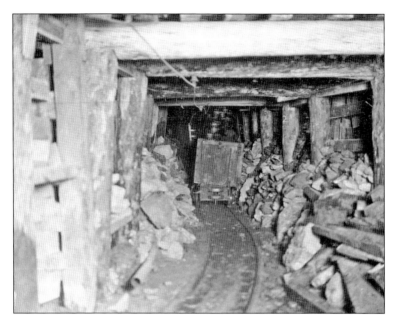

This view shows the initial excavation process for the inside bulkhead and rock packing in crosscut No. 9 West. Timbering was used as the thick wood withstood the tremendous pressure of exceptionally unstable ground. Throughout the duration of the project, timbering had to be periodically replaced. (Courtesy of Denver Water.)

This is crosscut No. 14 East inside the Moffat Water Tunnel. Double rows of reinforcing steel would eventually replace the timbering as the project progressed, and steel liner plates, shown at the top of page 96, gave the tunnel a more uniform look and provided protection from cave-ins. (Courtesy of Denver Water.)

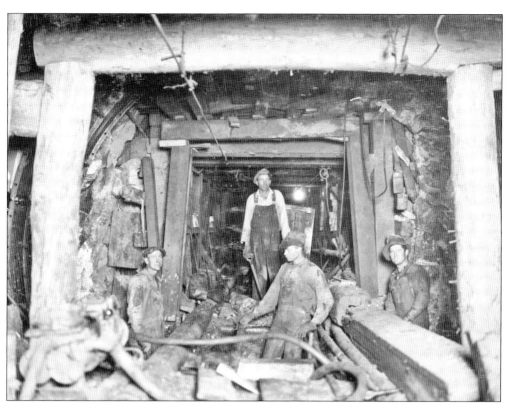

This view, looking east, shows Steel Lining Section No. 7. The men here are working towards expanding the pioneer bore of the Moffat Tunnel. In short, what lies under—and through—James Peak is a triple engineering accomplishment: the original pioneer bore, used to aid in the creation of the Moffat Tunnel, later was transformed into a water tunnel. (Courtesy of Denver Water.)

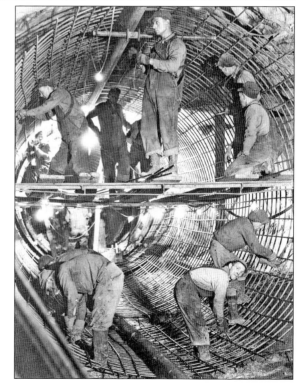

Inside the Moffat Water Tunnel, workers are placing double rows of reinforcing steel hoops in preparation to line the tunnel with concrete. At the top of the photograph appears a temporary pipe, which conveys concrete to the collapsible steel forms (the inner ring in the background). The permanent drainpipe at the bottom will conduct seepage water from the tunnel. (Courtesy of Denver Water.)

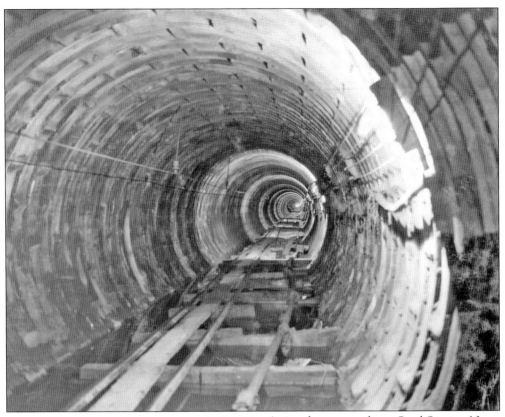

A timed exposure shows Steel Section No. 19 before its concrete lining was poured. The steel forms were collapsible, and Denver Water stated, "As the concrete hardened, the form in the rear was collapsed, moved ahead of other units and set in place, permitting constant, progressive pouring of concrete." (Courtesy of Denver Water.)

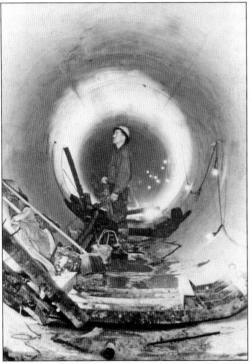

This section of the Moffat Water Tunnel, lined with concrete, is undergoing an inspection prior to equipment being moved from this area. After a severe drought in 1950, crews enlarged the Moffat Water Tunnel, and the previously unlined gravity tunnel on the eastern side was lined with concrete in 1958. (GCHA.)

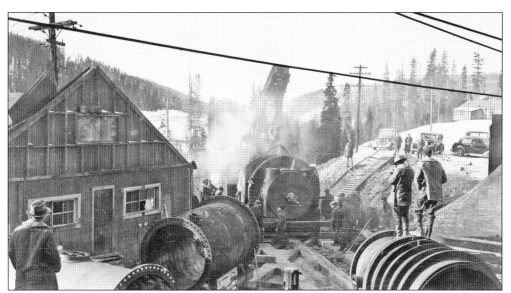

On January 28, 1937, this valve, one of the world's largest cone valves, was unloaded and placed on skids (above), where it was installed in the valve house at the West Portal of the Moffat Water Tunnel (below). Per Denver Water, "The inside diameter is 60 inches and the [roto]valve forms a greater than 10-foot cube, being 12.5 feet long, 10 feet wide, and 10.5 feet high. It is entirely constructed of steel and bronze and weighs more than 34 tons. Water from the Vasquez Collection System is conveyed across the Fraser River by a siphon and enters the valve at the right. Water at this point reaches a pressure of 110 [pounds] per square inch, the total pressure amounting to 311,000 [pounds]." (Both, courtesy of Denver Water.)

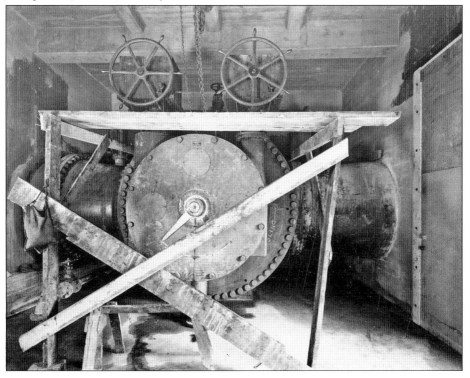

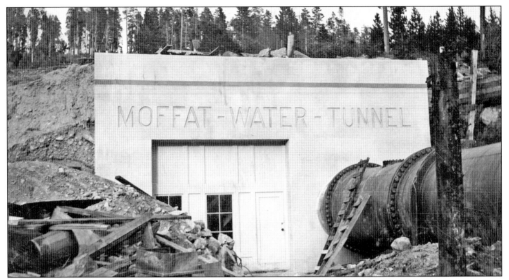

This look from May 16, 1937, pictures the valve house enclosing the 60-inch rotovalve at the West Portal of the Moffat Water Tunnel, described on page 97. This valve house can still be seen today; it is best viewed from a pedestrian overpass located at Winter Park Resort. (Courtesy of Denver Water.)

This December 1946 photograph shows what the ski area looked like during its seventh season. The Moffat Water Tunnel can be seen separating ski trails Parkway and Larry Sale as it descends the slopes and enters James Peak to the left of the West Portal arch of the Moffat Tunnel in the foreground. (USFS.)

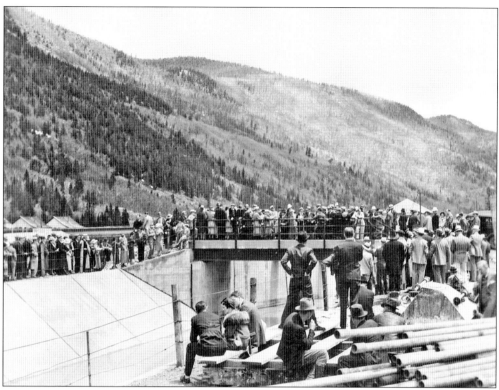

Above, on June 10, 1936, crowds listen to speeches at the East Portal as part of the opening celebration of the Moffat Water Tunnel. At left, the mountains that comprise the initial grades of Giant's Ladder for climbing Rollins Pass can be seen. Below, members of the Board of Water Commissioners congratulate each other. Pictured are, from left to right, M.C. Hinderlider, state engineer; Ben F. Stapleton, mayor; Herbert S. Crocker, consulting engineer; George M. Bull, state director, PWA; Stanley T. Wallbank, president of the Denver Chamber of Commerce and master of ceremonies; and Richard Wensley, president of the Board of Water Commissioners. A special train was chartered for the occasion by the Denver Chamber of Commerce. (Both, Courtesy of Denver Water.)

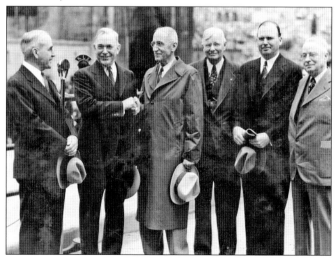

Contrast this image taken July 24, 1948, with the photograph at the top of page 43. More than three decades have passed and what was the highest standard-gauge railroad station in North America is now just a distant memory. Accounts show that the rails and ties were pulled up during a single summer in 1936—the law of entropy has never been kind to the Rollins Pass story. It is far easier to destroy than it is to build, and history can vanish too easily. Below, the telegraph poles near Ptarmigan Point that once held wires carrying important messages about wrecks, fires, and weather (as well as less urgent messages to friends and family) stand as silent sentinels on a hillside. The telegraph wires have worked loose and fallen to the ground, wisps of what they once were. (Both, USFS.)

Five

STEEL AND GASOLINE
1956–1990

Rollins Pass was far from forgotten, however. In 1956, Lieutenant Governor McNichols officially reopened Rollins Pass to vehicular traffic—one year before the beeping of *Sputnik* launched the Space Race. The Rollins Pass race, as it were, was to soak in the fleeting glow of summer before the snows of winter took hold once again. The US Forest Service worked alongside Boulder, Gilpin, and Grand Counties to make improvements to the road. Culverts were added and gravel was poured to improve washed out sections of road. The US Forest Service helped produce a self-guiding auto tour booklet corresponding with signs placed at noteworthy stops along Rollins Pass.

Anyone who traveled Rollins Pass during this period freely shares memories saturated with passionate nostalgia. The earliest travelers undoubtedly experienced the most authentic journey. For a few hours on an August Sunday, the family station wagon transformed into a powerful locomotive capable of climbing mountains. Just outside the open car window, the summer sun—which never seems to set—illuminates dust motes rising from the road, which circle lazily in the eddies. From the comfort of bench seats, one could see the magnificent trestles and snowshed debris, and upon closer inspection, discarded coal and railroad spikes could be seen on either side of the road, as if abandoned only yesterday.

In 1903, a small, hastily constructed timberline underpass was created by blasting apart metamorphic and igneous rock; a train would soon be coming through and there needed to be light at the end of Needle's Eye Tunnel. This high-altitude tunnel endured decades of intense freeze-thaw damage and ice wedging cycles since being structurally weakened by the explosions so long ago. These weathering forces, from time to time, liberate rocks from the crown of the tunnel. Some rockfalls were small, others more dangerous. The second time the tunnel closed, it was due to a significant injury: an amputation. The tunnel has been closed since 1990, eighty-seven years after being holed through and serving its intended purpose of sending trains up and over Rollins Pass.

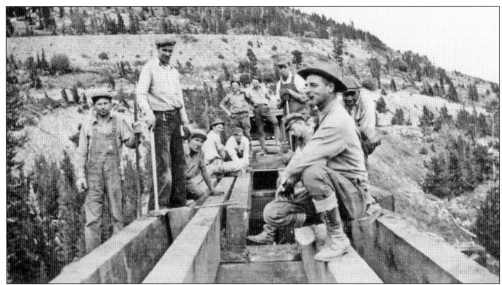

US Forest Service workers dismantle a trestle on the eastern side of Rollins Pass. Several sources cite mysterious fires and disappearances of buildings and structures on the pass. There is no mystery, however. The US Forest Service demolished these structures, including the dining hall at Corona, due to increasing costs of care and risk of liability. (Carnegie Branch Library for Local History.)

Many visitors, particularly from out of state, are not acclimated to the high elevations found on Rollins Pass. The lower atmospheric pressure (40 percent lower on the summit when compared to sea level) can cause altitude sickness, rapid dehydration, and if ignored can progress to high-altitude pulmonary or cerebral edema. Unexpected summer storms with violent lightning or sudden blizzards can also surprise tourists, who lose all sense of scale above timberline. (USFS.)

These numbered wooden signs mounted to railroad ties, right, are undergoing preparation to be placed vertically at notable points of interest on Rollins Pass (see the photograph at the bottom of page 106). Below, a posted sign advertises the Rollins Pass Auto Tour pamphlet. This guide was, and in many ways still is, a valuable turn-by-turn compendium to understanding how trains traversed Rollins Pass, especially since many components, like the tunnels and trestles, have collapsed or were removed. More recently, these signs were modernized to metal, but many have gone missing over the decades, requiring sightseers to make inferences as to where missing features belong on the historic route. In total, 28 points of interest were detailed in the first edition of this brochure. (Both, USFS.)

The Rollins Pass dedication on September 1, 1956, at the summit drew spectators and the following dignitaries (from left to right): Grand County clerk R.O. Throckmorton, Colorado lieutenant governor Steve McNichols, and Carl Lomax with J.D. Hart, of the Fish Department. Rollins Pass has served as a non-vital and seasonal recreational road ever since. (GCHA.)

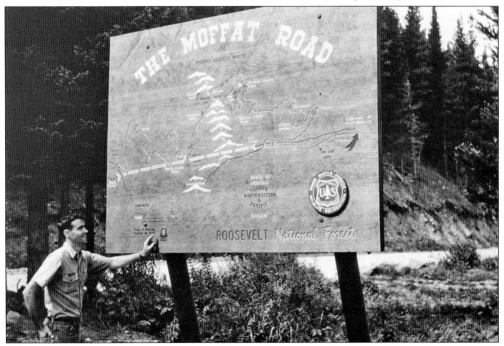

A large, wooden interpretive sign was placed on the lower east side of Rollins Pass, where it can still be seen today. The sign shows the abandoned and winding rail route contrasted with the straight shot via the Moffat Tunnel through the Rocky Mountains. Given the immense difficulties illustrated in chapter 3, the sign's subtitle of "Former Hell Hill Route" is an understatement. (USFS.)

The three rungs—three different grades—of the Giant's Ladder can be seen in these two photographs. These steep grades helped trains gain elevation quickly with little distance traveled. The steepness of what these grades looked like from the days when rails were installed can be seen at the bottom of page 30. Above, the signs on the restaurant in Tolland, Colorado, advertise Schlitz beer and Coca-Cola products. Tolland represented the first tourist stop west of Denver. From here, the air grows noticeably thinner and cooler, a huge draw for Denver tourists in the summer, yet the air also grows thicker with bated anticipation. (Above, GHS; below, USFS.)

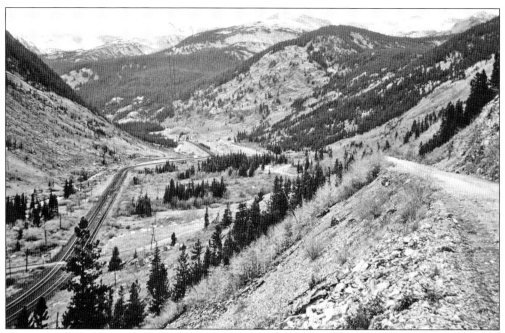

This is a view looking downhill from the first rung of Giant's Ladder to where the Moffat Tunnel enters the eastern side of James Peak. Halfway up the first rung (when viewed from satellite imagery) a severe indentation in the otherwise straight road gives away the location of a trestle that has since been removed; however, it can be found at the top of page 31. (USFS.)

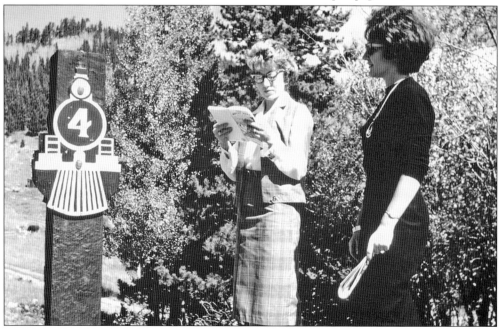

Tourists review the description at stop number four on the automobile tour: the square water tower and collapsed Tunnel No. 31. The water tower was needed only for construction efforts and was not used by the railroad itself; it unfortunately collapsed in 1991. Both features at this point of interest are on private property. (USFS.)

A silent landscape of the upper east side of Rollins Pass fills the windshield of the vehicle in this 1956 photograph. The road was formally opened to vehicular traffic earlier that year. This vehicle is a few turns away from Yankee Doodle Lake; the high alpine views from this point forward truly begin to impress. (GHS.)

Dixie Siding near Jenny (or Dixie) Lake served as the highest water stop on the east side. During the railroad era, this location was also used for mandatory examinations of both brakes and wheels. To conduct inspection, the crew would touch every wheel with their bare hands to ensure it was not hot to the touch. Wheels that glowed red, or caused discomfort when touched, required an obligatory cool-down period. (USFS.)

The reader can visually "thread the eye of the needle" by looking through the southwest portal of Tunnel No. 32 and seeing the opening for the northeast portal that ultimately led to the summit. Needle's Eye Tunnel is quite short and is the last remaining tunnel standing on Rollins Pass, although it too has begun to deteriorate. (USFS.)

This view of Yankee Doodle Lake shows the rails and ties removed from the roadbed. A cabin can be seen (it was later demolished) and the old toll wagon road deviates from the grade encircling the lake and instead heads east up the hillside to gain elevation before heading west-northwest (at the top left of the image) towards the Continental Divide. (USFS.)

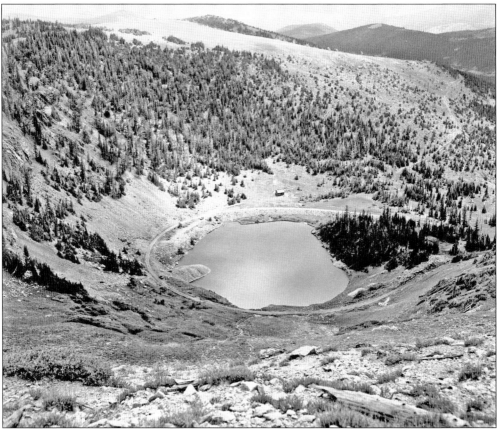

On Wednesday, August 3, 1955, the former Rollins Pass railroad grade was formally surveyed to establish it as a seasonal, non-vital recreational road. This is the same trestle shown on page 71. (USFS.)

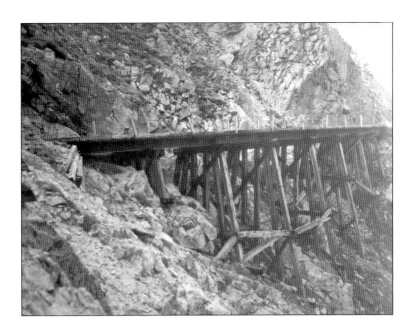

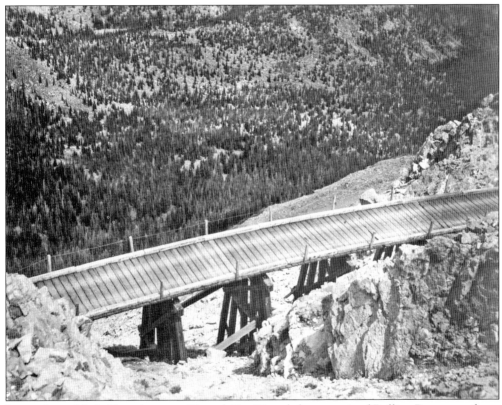

Located roughly halfway between Tunnel No. 32 and the summit of Rollins Pass, one of two magnificent wooden trestles that serviced rail traffic from 1904 to 1928 clings to a mountainside. These trestles were deemed strong enough to carry passenger vehicles for several decades; since 1982, the trestles have been closed to all forms of traffic except cyclists and hikers. (USFS.)

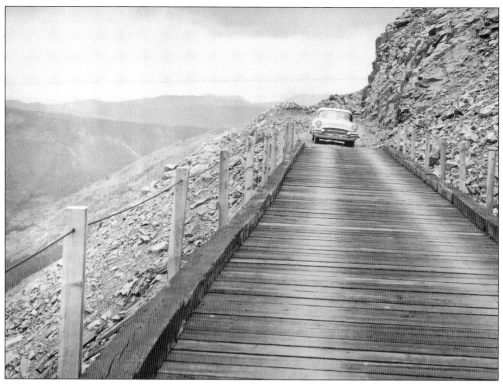

Train wheels have been superseded by car tires in this 1956 photograph of a vehicle beginning to cross the longer of the twin trestles heading uphill on the two percent grades towards Corona. Despite the motor vehicle instruction that uphill traffic has the right-of-way, this axiom is tested at other smaller cuts and blind curves in the mountainsides on Rollins Pass where a delicate dance is choreographed amid a flurry of signals shared by hand gestures, flashing lights, and friendly taps on the horn. Below, the intrepid explorers in the earlier photograph made it successfully to Corona, and the car is pointed towards the downhill leg of the journey towards Winter Park, Colorado. Of interesting note is the interpretive sign indicating the elevation of Rollins Pass to be 11,680 feet. (Both, GHS.)

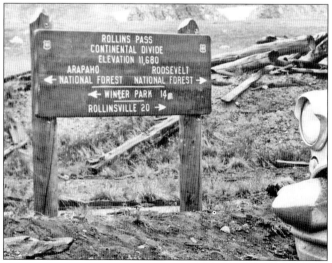

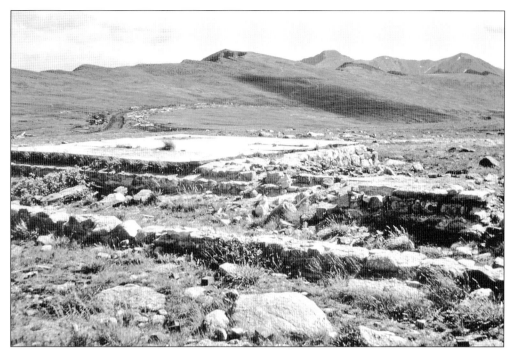

A 1952 geodetic survey placed a vertical control benchmark indicating an elevation of 11,671 feet (NGVD29), later 11,676.79 feet (NAVD88). The summit benchmark placement description reads, "At the old town site of Corona, 54 feet northeast of the center line of the old railroad grade, 1 foot above the ground, set in the top of the northwest corner of an abandoned 4x6 foot concrete foundation." Sadly, the benchmark was stolen. (USFS.)

A view near Ptarmigan Point looks towards the Loop Trestle. Ptarmigan Point is so named because of ptarmigans found at higher elevations on Rollins Pass. These birds are seasonally camouflaged to blend in with either granite rocks in the summer or snow in the winter; the bird is also unique in that its legs are feathered. (GCHA.)

This gem from the US Forest Service archives has been rarely seen by today's generation: this ¼-inch to 1-foot scale model was the proposed Rollins Pass Visitor Center, which would have been built north of the old dining hall at the summit on Rollins Pass. This model was made during the winter of 1963 by Joe Watkins and Wayne Parsons. Above, the roof is removed, providing a look inside. Below, the exterior with elevated deck would have faced the east (towards Boulder), and the impressive views of the Indian Peaks Wilderness Area would have been immediately visible to onlookers on the deck. Refer to both images on page 22 for the views near this spot. (Both, USFS.)

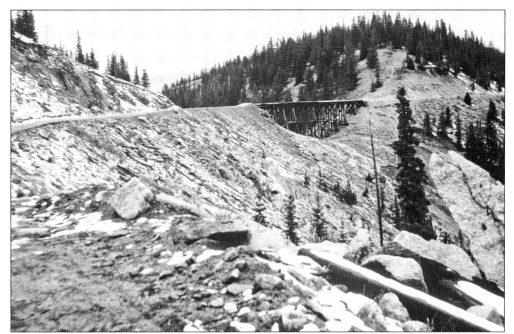

Here is a look at the Loop Trestle downhill towards Winter Park. Small, fur-bearing mammals call this rocky area near timberline home, including yellow-bellied marmots (a large ground squirrel), pine squirrels, chipmunks, mice, voles, gophers, and shrews. Other animals, such as the porcupine, emerge around sunset and can adroitly climb pine trees. (USFS.)

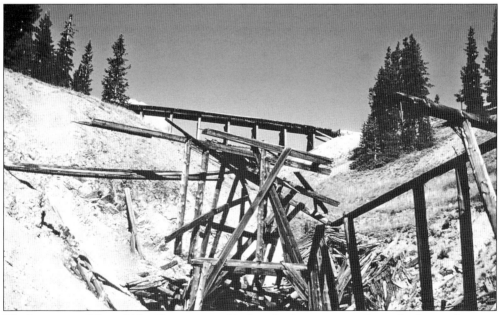

The last gasps of Tunnel No. 33 are pictured before the feature succumbs to the forces of nature. A short hike from here, locomotive debris (from spectacular wrecks that have taken place at the Loop) litters a boulder-strewn hummock. Two ramps exist where locomotives were rebuilt on-site and merged with the original grade; a third hidden ramp, less than a half mile away, was discovered by the authors and documented by archaeologists. (USFS.)

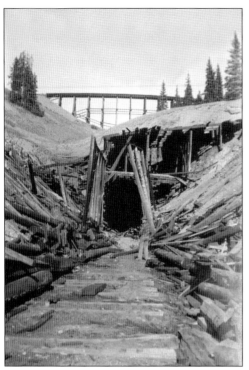

Tunnel No. 33, under the Riflesight Notch Trestle, continues its collapse. Cut through the Ranch Creek Fault, the tunnel was continually in danger of falling in on itself. When the railroad abandoned the over-the-hill route, the tunnel was no longer maintained and completely collapsed within a few decades. Surprisingly, the collapse of the tunnel did not seem to cause collateral damage to the trestle, which rests above the tunnel. (GCHA.)

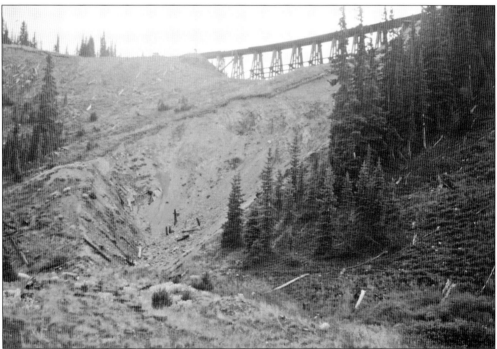

This is the obverse view of the Loop Trestle and Tunnel No. 33, seen in the previous image. A few remnants of wood framing from the tunnel can be seen protruding from the hillside; this was the exit portal prior to the collapse of the tunnel. The elevation loss or gain from one side of the tunnel to the other is noticeable. (GCHA.)

It is common for the summit of Rollins Pass to have three seasons—spring, summer, and autumn—within a matter of weeks. The summit can have waist-deep snow in July, and as soon as it melts and the grasses turn green, seemingly overnight the alpine tundra loses chlorophyll and transforms into a harvest landscape of browns, yellows, reds, and oranges. (USFS.)

Early travelers on Rollins Pass were treated to railroad relics: a snowshed vent rests on the tundra. These vents were installed 23 feet above the tracks, and the photograph at the bottom of page 45 provides a good look at the spacing of snowshed vents in operation at Corona. (USFS.)

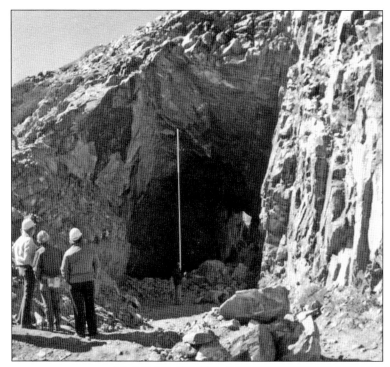

Engineers assess rockfalls in Needle's Eye Tunnel. The lack of rock bolts and wire mesh seems to indicate this was not the rockfall that occurred in 1990, despite it happening near the same place at the northeastern portal. Any modern plans to strengthen the tunnel would require varying amounts of shotcrete, and historic soot stains would sadly be covered up and forever lost. (USFS.)

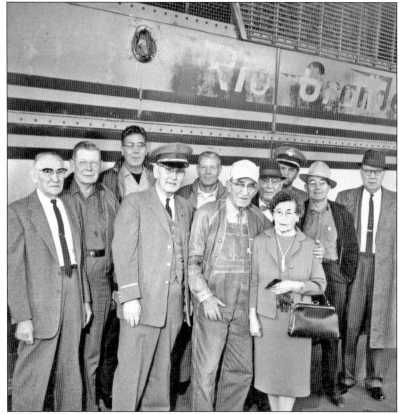

Railroader John Trezise, no longer working on trains but now a passenger, is pictured here in a white cap. The Trezise Collection of hundreds of seldom or never published photographs, viewed by the authors, provided a valuable look at railroading on Rollins Pass; Trezise also kept many of his train order forms and slip bills for both empty and loaded railcars. (Trezise.)

Six

PRESENT DAY AND LOOKING TOWARDS THE FUTURE
1990 ONWARDS

Wisdom from native peoples teaches that the earth is not inherited but is instead borrowed from the next generation. With Rollins Pass, society has been tasked with preserving a loan of immense cultural value—and vast fragility. The old rail line over the pass is listed as one of the most endangered sites in Colorado, and the threatened cultural resources on Rollins Pass need protection: not only railroad-era relics but also the older uses of the pass, including the wagon-era ruts and settlements as well as the game drive complexes built by Native Americans. Indeed, the overlapping layers of history on Rollins Pass are intricate and complex, and the public benefits from the professional archaeology work done by the US Forest Service, Colorado State University, and others. The Smithsonian also helps support the efforts of documenting, conserving, and protecting National Heritage Sites, including those on Rollins Pass.

This book helps to further cement the pictorial legacy of this resplendent place; this convenient crossing over the Southern Rocky Mountains is a crown jewel laden with history nestled in the Colorado high country. The wilderness of the pass, including the alpine tundra with its patches of scrappy krummholz, is precious and irreplaceable. The pass needs preservation so the next generations of visitors can enjoy this eternal porch on the Continental Divide; Rollins Pass is the public's collective heritage and it deserves respect, not indifference.

Stand anywhere on the mountains comprising Rollins Pass and one stands in the footsteps made by Native Americans, John Quincy Adams Rollins, David Moffat, Horace Sumner, George Barnes, John Trezise, James Benedict and Byron Olson, Jason LaBelle, the authors of this book, and many others. The fluttering pages of history unfurl to form an enduring tapestry—a shared story. Perhaps that is why Rollins Pass is so beloved: those who make the journey to bask in the magical beauty of this place and feel their souls restored in some small way reach across the infinite divide of time to uncover their own pioneering spirit on the dusty roads of Rollins Pass.

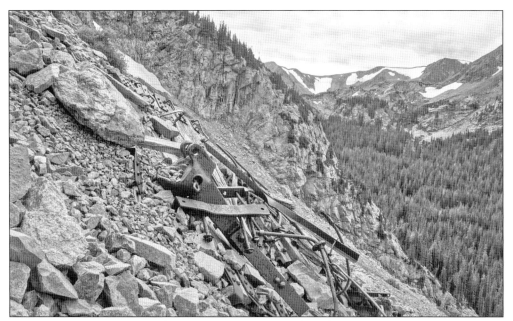

This wreck of an inside-braced, drop-end wooden gondola railcar was discovered by the authors and documented by archaeologists. It is virtually unreachable, exceptionally dangerous to access, and is located on a ~66-degree scree-covered slope. The wreckage includes slack adjusters, couplers, journal boxes, and more. As the wreck did not involve death or injury at the time it occurred, the incident was not reported to the Interstate Commerce Commission. (Authors' collection.)

Four splendid sets of ribbed-back train wheels—two of which are pictured here, one with considerable damage—survive a wreck on Rollins Pass. The spiral ribs dissipated heat generated from braking. The wheels display different maker's marks: Bass Ft. Wayne (2), Griffin (1), and Haskell and Barker Car Co[mpany] (1). The manufacture dates range from 1909 to 1913. (Authors' collection.)

There is good reason the roadbed of Rollins Pass is rough—the road prism contains both prehistoric and historic artifacts buried under the surface. Improving the road through regrading would first require sectional archaeological excavations. In several places, on or just under the surface, historical artifacts are covered with geotextile stabilization fabrics having characteristics that match the soil and permeability of the existing roadbed. (Authors' collection.)

Despite the removal of the rails more than eight decades ago, coal slag between railroad ties can clearly be seen on the road today in an alternating pattern of light and dark bands. Many foreign objects can be found in the road prism, including railroad spikes, nuts, bolts, washers, cotter pins, sun-colored amethyst glass, wagon-road era horseshoes, and more. As a reminder, please take only photographs, leave only footprints. (Authors' collection.)

A 170-foot-long bore through igneous metamorphosed migmatite and granite gneiss forms Tunnel No. 32. This infamous tunnel closed indefinitely in 1990 after a rockfall that resulted in a Denver firefighter's below-knee amputation. Rockfalls have made this tunnel unsafe, and it has been barricaded by authorities to prevent further injuries. Shifting and falling rock have made easy work of twisting chain-link metal deployed to prevent rockfalls. (Authors' collection.)

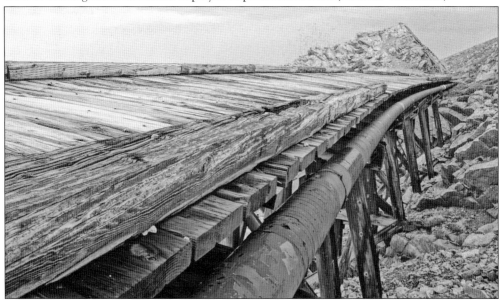

The durability of the twin trestles on Rollins Pass for the last century is proven and their future permanence is assured, as they are used to support an Xcel Energy natural gas pipeline. Coated with tape to aid against corrosion, the pipeline can be seen to the right of the trestle. (Authors' collection.)

The authors of this book (third and fourth from the right, standing) participated in a "Passport in Time" project with the US Forest Service in 2016 on Rollins Pass. The goal of the project was to "investigate the areas surrounding the railway and discover features that will fully illuminate and better preserve the route's historic legacy." (USFS.)

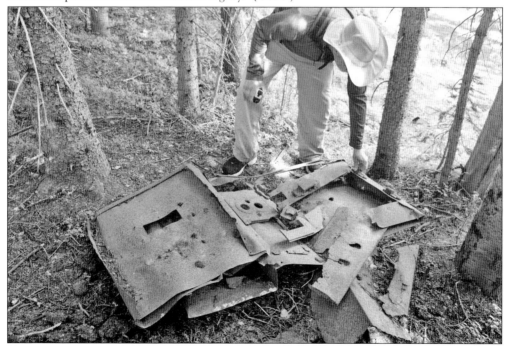

Historic artifacts were discovered by the US Forest Service Passport in Time volunteers, such as this oven in a railroad-era settlement. This site was largely undisturbed and contained the necessary clues to determine that the stove fit in context; animal bones, skillets, glassware, baking soda tins, and more helped establish the center of a historic kitchen. (Authors' collection.)

A US Forest Service vehicle provides a backdrop for a fallen telegraph pole. Detailed measurements of the site were taken, including the dimensions of the telegraph pole and storm braces along with submeter GPS coordinates to aid in the understanding of how this and other telegraph poles fit into the larger story of Rollins Pass. (USFS.)

Many glassware fragments on Rollins Pass are typified as sun-colored amethyst. This glassware started out clear due to the use of manganese as a clearing agent during the manufacturing process, but the glass turned varying degrees of purple depending on the amount of manganese used. Disposal of glassware is more difficult to date as some bottles were discarded immediately after use; others were kept and reused. (USFS.)

The story of Rollins Pass has been—and will continue to be—about people. As shown above, countless shoe soles can be found throughout Rollins Pass along with can dumps, as shown below. Changes in can manufacturing throughout the late 19th and early 20th centuries help make the discoveries of cans useful indicators of time at archaeological sites. Generally, solder-dot cans indicate a date of occupation prior to 1914 and an absence of sanitary cans suggests a date of pre-1904. The importance of leaving artifacts behind—even if they appear to be rusted trash—is vital; the study of cans helps date an occupation on Rollins Pass. Archaeologists turn trash into science, one can at a time. (Both, USFS.)

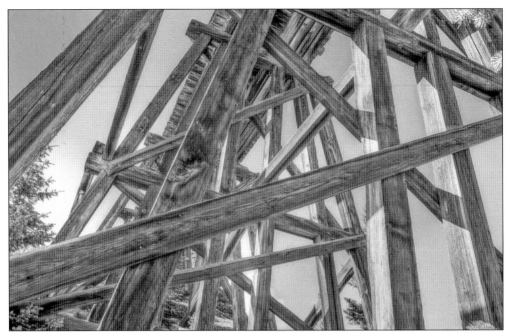

The intricately engineered complexity seen up close and underneath the Loop Trestle belies the straight lines of the same trestle seen at the top of page 114. The vertical piles, along with the horizontal and sway bracing, create a multidimensional maze that supported active rail traffic on Rollins Pass for more than two decades. (Authors' collection.)

In the United States, rail is weighed by the yard; 90-pound rail weighs 90 pounds per yard and was used from Denver through Tunnel No. 31 and 85-pound rail was used from that point west. This discarded rail was discovered by the authors, documented by archaeologists, and measures more than 5.583 yards. This rail is located west of Tunnel No. 31 and is thus 85-pound rail; therefore, this segment weighs close to a quarter ton. (Authors' collection.)

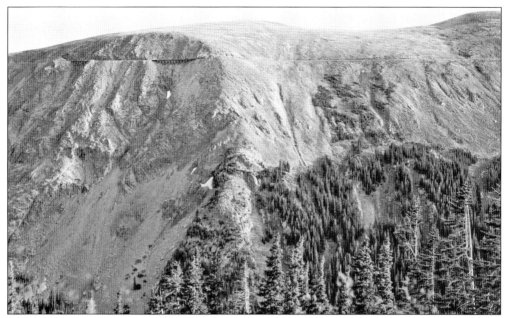

Rollins Pass imparts a mirage of impregnable durability. Apathy is destructive, and the landscapes—lakes, rivers, streams, waterfalls, and even artifacts—are fragile. The seven Leave No Trace principles help ensure the next generation can enjoy this historic place: plan ahead and prepare, travel and camp on durable surfaces, dispose of waste properly, leave what you find, minimize campfire impacts, respect wildlife, and be considerate of other visitors. (Authors' collection.)

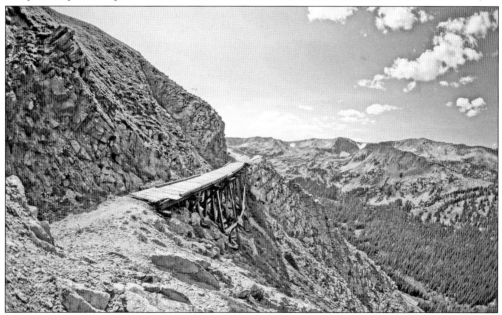

Throughout millennia, the eternal landscape of Rollins Pass has been a witness to the traveler. From the soles of Native American feet, to Rollins himself and the clip-clopping of beleaguered horses pulling wagons, to steel train wheels, and the vulcanized rubber tires of motor vehicles and beyond, this slice of Colorado wilderness radiates wonder. The current generation has a responsibility to cherish and treasure this land for future epochs. (Authors' collection.)

Bibliography

Albi, Charles, and Kenton Forrest. *The Moffat Tunnel: A Brief History*. Golden: Colorado Railroad Historical Foundation, 2002.

Bollinger, Edward T. *Rails That Climb*. Boulder, CO: Johnson Publishing Company, 1979.

Bollinger, Edward T., and Frederick Bauer. *The Moffat Road*. Athens: Ohio University Press, 1981.

Boner, Harold A. *The Giant's Ladder*. Milwaukee: Kalmbach, 1962.

Crossen, Forest. *Western Yesterdays: David Moffat's Hill Men*. Fort Collins, CO: Robinson Press, Inc., 1976.

Denver Board of Water Commissioners. *Denver Trans Mountain Fraser River Diversion Project*. Denver: Denver Board of Water Commissioners, 1938.

Fullenkamp, Larry. "Rollins Pass Archaeology." Interviews by authors. July, October, and November 2016.

———, comp. *Rollins Pass PIT Project 2016*. US Forest Service.

Griswold, P.R. "Bob." *David Moffat's Denver, Northwestern and Pacific*. Denver: Rocky Mountain Railroad Club, 1995.

———. *The Moffat Road 2-26-28*. Aurora, CO: Double R Publishing, 2010.

Hitchcock, F.C., and C.C. Tinkler. *The Contractors' Story of the Moffat Tunnel: Not an Engineering Treatise*. Denver: Hitchcock & Tinkler, 1927.

LaBelle, Jason. "Rollins Pass Archaeology." Interviews by authors. December 2012–December 2017.

McMechen, Edgar Carlisle. *The Moffat Tunnel of Colorado: An Epic of Empire*. Denver: The Wahlreen Publishing Company, 1927.

Nicklas, Tim. "Rollins Pass History." Interview by authors. January 2017.

Sundquist, Elizabeth Josephson. *Dismantling the Rails that Climbed*. Denver: Egan Printing Company, 1994.

ABOUT THE ORGANIZATION

Preserve Rollins Pass strives to fulfill a Native American adage: "In every deliberation, consider the impact of decisions on the next seven generations." Both prehistoric and historic preservation are paramount; these goals are achieved through active volunteer outreach, education, archaeology, and technology. Preserve Rollins Pass relies on the expertise and direction of agricultural and archaeological professionals who study the area to advise how Rollins Pass should be best preserved now and far into the future. This book contributes to the preservation of Rollins Pass using technology: a legacy of more than 1,750 photographs, maps, and documents were scanned at extremely high resolution, saving them from loss. Preservation also starts with the reader; Preserve Rollins Pass facilitates straightforward access to archaeologists who have a vested interest in preserving the heritage of Rollins Pass. Should any item of historical or prehistorical value be found, please e-mail contact@preserverollinspass.org, and the message will be forwarded to area experts, including Dr. Jason LaBelle. To find out more or learn how to help, please visit preserverollinspass.org.

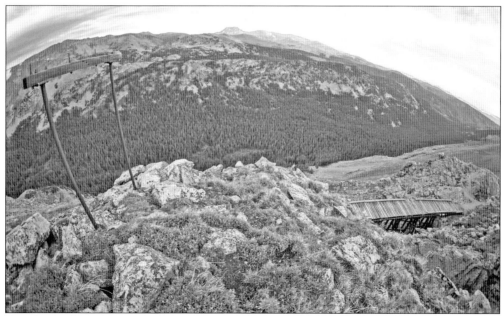

A telegraph pole stands high above a trestle on the east side of Rollins Pass. (Authors' collection.)

DISCOVER THOUSANDS OF LOCAL HISTORY BOOKS FEATURING MILLIONS OF VINTAGE IMAGES

Arcadia Publishing, the leading local history publisher in the United States, is committed to making history accessible and meaningful through publishing books that celebrate and preserve the heritage of America's people and places.

Find more books like this at
www.arcadiapublishing.com

Search for your hometown history, your old stomping grounds, and even your favorite sports team.

Consistent with our mission to preserve history on a local level, this book was printed in South Carolina on American-made paper and manufactured entirely in the United States. Products carrying the accredited Forest Stewardship Council (FSC) label are printed on 100 percent FSC-certified paper.